soviet

Socialist Realist & Nonconformist Art

DIS UNION

The Museum of Russian Art April 20 - August 19, 2006

Published by

TMORA

The Museum of Russian Art
Minneapolis, Minnesota

Curator and Installation Designer | Reed Fellner

Catalog Text | Maria Bulanova
Dr. Alla Rosenfeld

Translator | Dmitrii Fedosov

Essay Editor | Jane Friedman

Editor and Publishing Coordinator | Joan Lee

Catalog Design | Bill Moeger, Moeger Design

Color Management | System Color Services

ISBN: 0-9721493-2-5
Library of Congress Control Number: 2006921873

© 2006, The Museum of Russian Art
5500 Stevens Avenue South, Minneapolis, Minnesota 55419

Printed in China

Soviet Dis-Union:
Socialist Realist and Nonconformist Art

Dedication

To Raymond E. Johnson and Norton T. Dodge

This exhibition and catalog are dedicated to the visionaries whose

passion for twentieth-century Russian painting and sculpture are providing

an artistic legacy to the American people.

The collections of Raymond and Susan Johnson and Norton and Nancy Dodge

offer insights into a particular time and place in history,

as seen through the eyes of the artists who witnessed and recorded them.

Soviet Dis-Union:
Socialist Realist and Nonconformist Art

In June 1990 Mikhail Gorbachev, General Secretary of the Communist Party of the Soviet Union, received an enthusiastic welcome in Minneapolis, Minnesota, from tens of thousands of Midwestern Americans attracted by the appearance of an international political leader and celebrity personality. The composition of the crowd ranged from casually curious individuals spontaneously attracted by Mr. Gorbachev's motorcade to politically energized observers seeking a glimpse of the "new" Russian leader. The words *glasnost* and *perestroika* had already entered the American vocabulary. They served as shorthand terminology to describe a series of liberalizing policies that led to an increased openness and expansion of individual freedoms in Soviet society. As a result of *glasnost* and *perestroika*, the political, economic and cultural parameters of Russian life increasingly became subjects of international attention and change.

In retrospect, Mr. Gorbachev's trip also initiated a cultural tidal change in Minnesota. An underlying social curiosity about all things Russian began to emerge from the confrontational rhetoric and cultural isolation that had characterized American-Soviet relations during the Cold War. Minnesotans observed area companies pursuing large-scale commercial projects in the Soviet Union, international air service was extended to Moscow, and the level of local tourism to Russia increased significantly.

1991 witnessed the dissolution of the Soviet Union. It also marked the start of a unique cultural venture: the beginning of Raymond E. and Susan J. Johnson's collecting activities in the area of Russian art.

Utilizing his thirty years of experience as a successful dealer and collector of twentieth-century American paintings, Mr. Johnson recognized that an informational vacuum existed within the academic and commercial art communities regarding the scope and quality of Soviet realist art. In 1991, following several years of preliminary research, Mr. Johnson held an exhibition and sale of Socialist Realist art in Minneapolis. What started out as a modest experiment based on Mr. Johnson's personal fascination with Russian realist art evolved into a life's mission manifested in the creation of the most comprehensive private collection of Socialist Realist art in the world. During the course of some forty trips to Russia, Mr. Johnson constructed an encyclopedic collection of official art from the period 1930 to 1985. In 2002, the Johnsons founded The Museum of Russian Art (TMORA) to institutionalize their personal collection and to ensure the professional organization of exhibitions and educational outreach events. TMORA has developed relationships with leading American, Russian and other international museums through the loan and display of Russian paintings, icons and related forms of visual art.

In 1955 Norton T. Dodge accompanied his father on his first trip to Russia and began an art odyssey perhaps unrivaled during the twentieth century. In the 1960s, Mr. Dodge became a professor of Economics at the University of Maryland. While researching the economic status of women in the post-Stalin Soviet economy, Professor Dodge became infatuated with the contemporary work of nonconformist artists which challenged the limitations of subject matter and style imposed by the Soviet government. For almost twenty years, Professor Dodge personally traveled throughout the Soviet Union meeting with artists and purchasing the work of an estimated six hundred individuals whose art has been described as "...not so much [paintings] of an era as the era itself."[1] Disregarding the ever-present threat of the KGB security service, Professor Dodge assembled a diverse collection of nonconformist paintings and sculptures that includes examples of work from the most significant artists of the movement. The Norton and Nancy Dodge Collection of Soviet Nonconformist art has been donated to Rutgers University and is on permanent display at the Jane Voorhees Zimmerli Art Museum in New Brunswick, New Jersey.

It is perhaps one of the most poignant ironies of art history that twenty years after the beginning of *perestroika* the two most significant collections of Soviet era art form the core of two American art museums. The Museum of Russian Art and the Jane Voorhees Zimmerli Art Museum have collabo-

Photo by Don Wong

The Museum Of Russian Art

rated to create *Soviet Dis-Union: Socialist Realist and Nonconformist Art* to visually depict the vibrant diversity of art created in twentieth-century Russia.

The Museum of Russian Art is organized as a private, nonprofit educational institution dedicated solely to the preservation and presentation of Russian art and artifacts. Our program of continuous exhibitions, lectures and supporting events recognizes that the American public has relatively limited knowledge of Russian history and even less of an awareness of Russian artistic traditions. For almost three generations the Soviet and non-Russian art communities coexisted in a state of mutual disregard, if not outright disrespect, for the artistic accomplishments of their counterparts.

The philosophical competition between communism and democracy polarized the critical assessment of artistic developments within both the Soviet Union and the United States. Soviet government representatives routinely rejected contemporary American art as overtly commercial, artificially stylized and socially non-productive. Western government and academic art critics dismissed Soviet paintings as aesthetically obsolete, blatantly proselytizing and the products of a spiritually oppressive system of social control. The minimal level of artistic cultural exchange programs between the Soviet Union and the U.S. during the second half of the twentieth century fostered the simplistic notion among Americans that all Soviet art consisted of monumental portraits of revolutionary leaders or strident posters of heroic workers.

The death of Stalin and the Khrushchev thaw of the mid-1950s and early 1960s prompted important changes in contemporary Russian painting. The relaxation of some elements of Soviet social control contributed to the emergence of a loose-knit group of artists variously, and interchangeably, identified as dissident, unofficial, underground or nonconformist whose work incorporated a conscious motivation to reject or refute official Soviet government policies and social objectives.[2] Amid the climate of Cold War politics, some Soviet critics positioned these artists and their works as the true agents of artistic expression in Russia, personifying the unconquerable human spirit within a repressive regime.

Soviet Dis-Union: Socialist Realist and Nonconformist Art has been organized to provide a unique opportunity to view outstanding examples of both official and nonconformist art created during the late Soviet period. The principal objective of this exhibition is to challenge current artistic paradigms by displaying the diversity, creativity and technical brilliance that is incorporated in both Socialist Realist and nonconformist art. The exhibition presents examples of the two internally competing views of contemporary life in the Soviet Union, providing a cross section of the art of the period as a mirror of a society that was largely isolated from most Americans at the time.

1991 marked the dissolution of the Soviet Union. This event effectively terminated the unique system of government philosophical and artistic support that defined Socialist Realist art which, by extension, gave rise to nonconformist art as a reaction against it. The internal dynamics of political and social development within the Russian Federation in 2006 are clearly still in a state of change. *Soviet Dis-Union: Socialist Realist and Nonconformist Art* is presented with the expectation that the critical assessments of these artworks can be conducted in a less emotionally charged environment than existed as recently as two decades ago.

The re-evaluation of major schools of art proceeds at a pace equal to that of tectonic plate movements. Two decades of revised perspective is arguably too short a time to fairly judge the historical significance of Soviet art, but that reappraisal is, in fact, in process. Educators often refer to what has been called "the teachable moment." This exhibition may be considered just such an opportunity. Raymond Johnson and Professor Norton Dodge share a common passion for the vibrancy, creativity and technical expertise of twentieth-century Soviet painting. Their respective collections are artistic legacies to the American people and you are invited to share a portion of their lifes' work.

Bradford Shinkle, IV

President

The Museum of Russian Art

[1] John McPhee, *"The Ransom of Russian Art"*, New Yorker Magazine, serialization, 81.

[2] Valerie L. Hillings, *"Official Exchanges/Unofficial Representations: The Politics of Contemporary Art in the Soviet Union and the United States, 1956-1977"*, 350, "Russia" catalog from the Guggenheim Museum, 2006.

On Collecting Socialist Realist Art

In the late 1980's my wife, Susan, and I acquired several Russian Impressionist paintings that began what has become our passion for collecting Russian art. Having long admired the creativity of Russian writers, musicians and dancers, we found ourselves energized by the color and composition of twentieth-century Soviet realist art. Our collection started as a modest venture into the area of international fine art; it has become one of the compelling interests in our lives. The Johnson Collection has evolved into a broad-based compendium of Russian and Soviet paintings covering the past one hundred years.

Our personal interests have favored mid-twentieth-century representational painting, and our collection of Socialist Realist works is the largest outside the former Soviet Union. However, our collection does include examples from the imperial, avant-garde and post-Soviet art periods as well. Each of these segments of Russian artistic history reflects dramatic alterations of Russian social, economic and political conditions that were dramatically different from those in successive eras. The historical conditions that preceded the Russian revolution in 1917 and evolved over the following seventy-five years placed an indelible stamp on the entire development of Soviet-era art.

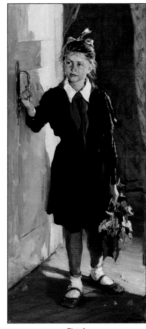

Fig. 1
Young Pioneer at the Door, 1955
Fedor Vasilievich Shapaev

Socialist Realist art chronicles the social evolution of three generations of Russian people that endured the combined upheavals of political revolution, foreign invasion and domestic repression. As an individual collector, I recognize the need to separate my appreciation of the results of Soviet painting from my personal judgment of the political system that created these paintings. I submit that an objective appreciation of the technical expertise and creative energy found in authorized Soviet art can be conducted without excusing the crimes against the Russian people conducted by the Communist Party. The Johnson Collection captures the intensity of basic human aspirations that are not restricted by arbitrary national boundaries or transient artistic styles.

In 2002 The Museum of Russian Art was founded as a means of sharing our enthusiasm for Russian art with the public. The Norton T. and Nancy Dodge Collection of Nonconformist Art has justly earned international praise for the depth and scope of its holdings. We are pleased to be able to introduce the exhibition *Soviet Dis-Union: Socialist Realist and Nonconformist Art* as a unique opportunity to view powerful and historically significant artworks from the two great American collections of twentieth-century Russian art.

Sincerely,

Ray E. Johnson

Ray E. Johnson

TMORA

On Collecting Nonconformist Art

I welcome this opportunity to share with you the important elements of how I became an avid collector of unofficial, nonconformist and dissident Soviet art. As a young man I expected to become an artist but subsequently developed an interest in economics and international affairs. I became convinced that the greatest challenge facing the United States during my lifetime would be the Soviet Union. I completed my education at Harvard University, receiving a Masters degree in Russian Regional Studies and a Ph.D. in Economics. My first trip to the Soviet Union in 1955 focused on observing the Soviet educational system; subsequent visits included the study of the Soviet economy but increasingly my attention turned towards the discovery of Soviet dissident art.

Previously I had convinced myself that in a nation that had produced so many outstanding and creative minds there must surely be a group of talented artists suffering under the restraints of Communist Party authority. I was inspired after reading a *Life* magazine article titled "The Art of Russia that Nobody Sees" and became determined to document this chapter of art history. Beginning with my next trip in 1962 and continuing through successive visits in the 60s and 70s, I met most of the artists featured in the *Life* article and many others throughout the Soviet Union. My visits with the artists were risky for me and even more so for the artists since they faced harassment, possible loss of employment, imprisonment, consignment to a mental institution, physical injury or death. With the help of former embassy personnel, Soviet émigré artists and many other similarly motivated individuals, I amassed a substantial collection of nonconformist art from the Soviet Union.

Fig. 2
Baltika, 1973
Alexander
Kosolapov

During the 50s and 60s nonconformist art received very limited public exposure in the West. My wife Nancy and I undertook the challenge to increase its visibility by organizing various exhibitions at university and public museums beginning in 1976, including a large, well-received traveling exhibition in 1977 accompanied by a 127-page illustrated catalog. In 1980, I established a nonprofit gallery in New York where ten exhibitions and five illustrated catalogs were produced. Later I collaborated with the C.A.S.E. Museum in New Jersey, producing a number of exhibitions and catalogs. The Dodge Collection continued to expand and rapidly outgrew the facilities at our farm in Maryland. Providentially, Dennis Cate, Director of the Zimmerli Art Museum at Rutgers, the State University of New Jersey, recognized the merit and significance of the collection. Mr. Cate invited us to donate our collection to the Zimmerli Museum that provides professional management for a collection that now includes over twenty thousand individual works representing nearly two thousand artists from throughout Russia and the former republics of the Soviet Union. The collection provides the basis for research, undergraduate and graduate courses and large and small rotating exhibitions.

The nonconformist artists became a major element of the dissident movement that emerged in the Soviet Union and contributed to its eventual collapse in 1991. I always felt a powerful attraction to these courageous artists who defied the authorities and gave the intimidated populace the encouragement to confront authority and gain freedom.

Sincerely,

Norton T. Dodge

Norton T. Dodge

Soviet Art: **A Perspective on a Twentieth-Century Phenomenon**[1]

By Maria Bulanova

The twentieth century transformed our ideas about the world and our place in it to an almost unimaginable degree. Values that had long underpinned European and Russian culture were overturned and supplanted amid the devastating world war and the revolutionary upheaval that shook Russia and parts of Europe during the first two decades of the century. In place of Enlightenment, ideals founded on the belief in human progress and the notion that man was the crowning achievement of divine creation by which all creation was measured, there emerged a new set of values that diminished man's role in favor of the collective and asserted that only what was visible was the truth. This collectivist, materialist worldview was first advanced by the early-twentieth-century avant-garde and later provided the foundation for the art of the totalitarian regimes, especially that of the Soviet Union.

The embrace of the new twentieth-century *weltanschauung* is among the many common elements Soviet art shares with the avant-garde. While often regarded as an aberrant product of the Communist regime, Socialist Realism (or, as I often refer to it throughout this essay, "the art of the Soviet period" or merely "Soviet art," as the term "Socialist Realism" is not universally accepted and has aroused considerable debate) in many ways was a continuation of the revolutionary avant-garde—and in fact should be seen as the final avant-garde project. Socialist Realism regarded art as a key ideological weapon in the service of the Soviet state,[2] dedicating itself to the convincing portrayal of the myth of the Communist utopia[3] (Fig. 3).

Avant-garde art and Socialist Realism have common artistic and philosophical origins. Both were rooted in late-nineteenth-century Art Nouveau and Symbolism and in the theosophical concept of creativity, which exerted an enormous influence on many noted turn-of-the-century artists (as well as politicians), including Pablo Picasso, Edvard Munch, and the Russians Kazimir Malevich, Vasilii Kandinsky and Kuzma Petrov-Vodkin. A body of thought developed in the last decades of the nineteenth century, theosophy proclaimed a belief in hidden forces ruling the universe, and in man's psychic energy and ability to travel through time and space. Its central principle was that art should transform the social order, and that the full harmony of mankind on earth would be achieved through a synthesis of all the arts. This concept gave rise to the utopian vision, promoted first by the avant-garde and later Socialist Realism, of a new universal religion and state where all people could enjoy happiness.

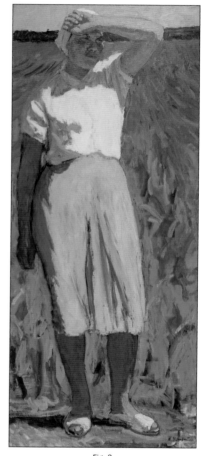

Fig. 3
Team Leader, 1956
Vasilii K. Nechitailo

[1] This essay was translated from the original Russian by Dmitrii Fedosov. The editors have inserted a few explanatory footnotes to aid non-specialist readers.

[2] The importance of Soviet art as an ideological weapon is reflected in the fact that the state early on sought to maintain strict control over all forms of aesthetic production, nationalizing all private collections, museums, educational institutions, and the mass media. It also came to institute tight censorship, which included prohibiting particular forms and movements deemed anathema to the goals of Socialist Realism.

[3] Every genre in Soviet art, depending on its position in the aesthetic hierarchy, was expected to perform specific functions in the service of this myth. The portrait reflected the image of the leader and the New Man; historical painting, the heroism of battle; and landscape, the grandeur and beauty of the Soviet Motherland.

Another important influence on the Soviet avant-garde and, later, Socialist Realism, was Italian Futurism. Like theosophy, Futurism regarded art as a means of transforming society. (In the words of Filippo Marinetti, the leader of the movement, art was "inspirational alcohol.") Driven by their view of art as the vehicle for the total reconstruction of the world, the Futurists wrote that every new generation should create new cities. Malevich seized on this idea, calling for the destruction of old cities every fifty years for the sake of the eternal rejuvenation of mankind.

While the Italian Futurists looked to the First World War, militarism, and modernity for regeneration, the Soviet avant-garde focused its attention on the October Revolution. Avant-garde artists led the way in supporting the revolution, devoting their efforts almost from the outset to the revolutionary cause and the creation of a new socialist society. They also adopted the most radical artistic stance. Avant-garde theorists likened the artist to a worker whose role was to produce objects necessary for the revolution and the working classes. Perhaps even more important, the artist was also charged with an educational role–the propagation of Communist ideology among the nation's far-flung masses. This concept of the artist as educator/agitator recalls the example of the nineteenth-century Russian Itinerant painters, who saw as their mission the enlightenment and education of the Russian rural populace. It later served as the foundation for Soviet art, especially from the mid-1930s onward.

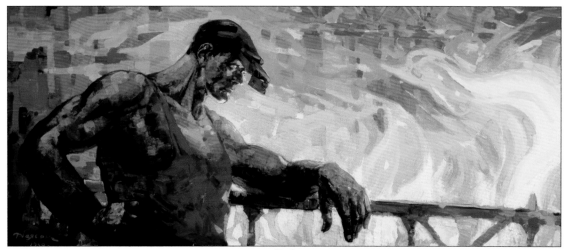

Fig. 4
A Guy from the Urals, 1959
Vasillii A. Neyasov

In propagating Communist doctrine, the Soviet avant-garde and its Socialist Realist successor sought to transform the human psyche–or, in the parlance of the period, effect the "psychic construction" of the nascent Soviet people.[4] The ultimate goal of psychic construction was the creation of the New Man, the worker who was the anticipated cornerstone and leader of the new Soviet society. Described in avant-garde manifestoes, the New Man was characterized above all by his collectivist outlook. He was to be completely identified with the revolutionary cause, maintain a correct working-class consciousness, assimilate with the masses, and wholly adapt his interests and goals to those of the Soviet state.[5] As such, he was to be purged of individualistic qualities like emotion and lyricism as well as an interest in items or concepts superfluous to the new way of life (Fig. 4). For this reason, the avant-garde artist Varvara Stepanova eliminated any concern with individual identity in her clothing designs for the New Man. Her geometric designs, which envisaged only two kinds of wear–labor and rest–disregard the actual form of the human body and the aesthetic question of whether the clothes would be "becoming" or not.

[4] This was explored by the Central Institute of Labor. Founded in 1921, the Central Institute of Labor used mathematical methods to work out a system for transforming the human psyche by means of art.

[5] Cinema played an important role in Soviet culture. Its propagandistic potential was recognized early on by the new regime. Lenin famously stated, "Of all the arts, cinema is the most important," while Stalin exerted personal control over and pronounced his directions on film, including the work of the noted director Sergei Eisenstein.

Perhaps paradoxically, alongside this pursuit of collectivism and rejection of human individuality, there emerged Soviet avant-garde artists with enormous, often idiosyncratic personalities who–much as the state soon would–sought to exert total ideological control over artistic production. Pavel Filonov, the famous outsider of the avant-garde, insisted that "Art must function...within a single state plan".[6] The avant-garde leader Kazimir Malevich wished to create a new system of beliefs based on his movement, Suprematism, which for him was not merely a mode of painting but the basis for transforming everyday life. Malevich's oversized personality and ambition are captured in the following excerpt from the diary of the painter Evgenii Katsman, a faithful adherent of cultural policy who was well acquainted with influential politicians and even had a private studio inside the Moscow Kremlin. Katsman and Malevich had, most interestingly, married into the same family[7]–a fact that did not preclude the two from hating each other, as both men aspired to the role of ideological leadership. In Katsman's words:

> After the October Revolution the pauper Malevich became an important leader, one of the outstanding figures of Soviet art, even though there was nothing Soviet about him. They–Futurists, Suprematists, abstractionists–thought that the October Revolution was not interesting enough to become the subject of their art, and so made their own revolution within art. They overthrew and tried to overthrow Realism and all art in general, and instead of what humanity had managed to achieve in a whole millennium, instead of classical art, instead of masterpieces by Raphael, Rembrandt and Repin, they thought they would give us new "revolutionary-abstract art." Now we are fighting against abstract art, but during the first five years of Soviet life we had that kind of loathsome stuff in art. People began to buy those "little squares" of Malevich; he finally got the happy life that he wanted. Now he has good clothes and shoes. He began to lead Soviet art. He published articles and brochures. He made incomprehensible speeches, but with the eyes of a fanatic; a group of followers appeared around him, only because a little square could be made by anyone, even by a total idiot. Malevich became rich, while we, realists, during the first five years were going around poor and starving. Only people like Malevich, Tatlin, etc., sold their paintings....Once I accidentally met Malevich near the Pushkin monument. Malevich told me: "Now we have the Socialist system, then we'll have the Communist one and after that–the Suprematist-Abstract." I looked at him closely–the eyes of a fanatic; there is no use arguing with him. He knew nothing about Marxism, he had never read anything. He created abstract art....I had little to argue about with Malevich. He considered me a nonentity, and I him, a fanatic and a good-for-nothing.[8]

As suggested in Katsman's passage, the avant-garde enjoyed a brief period of dominance in the Soviet art world. However, beginning in the mid- to late 1920s, the state took measures that marginalized the movement. The avant-garde's fate was sealed the following decade. In 1932, the Central Committee of the Communist Party issued the decree "Concerning the Reform of Literary-Artistic

[6] Pavel Filonov, as cited in Igor Golomshtok, *Totalitarian Art* (Moscow: Galart, 1994), 32.

[7] This historical fact reflects the disjuncture that existed in Soviet society. The two artists, along with Dmitrii Toporkov, a talented representative of traditional realism, married the three daughters in the Rafalovich family. Katsman married Evgeniia, the eldest of the three sisters; Malevich married Sofia, the middle sister; and Toporkov wedded Maria, the youngest. In accordance with Katsman's will, the full text of his diary can be made public several years from now. However, the fragments of this document accessible today already provide us with valuable information on the period of the 1920s and 1930s.

[8] Evgenii Katsman, as quoted in T. Khvostenko, *Vechera na Maslovke bliz Dinamo. Za fasadom proletarskogo iskusstva*, vol. 2 (Olympia Press, 2003), 161-62.

Organizations," ordering the dissolution of all artistic groupings and the creation of the single Union of Artists of the USSR (Artists' Union). Two years later, this was followed by the announcement of Socialist Realism as the official form of Soviet art.

There were several reasons for the downfall of the Soviet avant-garde and its failure to achieve the status of official Soviet art. For one, by the late 1920s the avant-garde as a creative concept had been losing ground and had increasingly become a play of forms. Another contributing factor was the arcane visual language of avant-garde art, which the government regarded as inaccessible and therefore inadequate to the task of educating the Soviet masses. Lenin himself labeled all modern art movements "Futurism," characterizing them as the revolt of the "insanely overfed" bourgeois intelligentsia. In 1919, one of Lenin's closest associates, the Bolshevik leader Grigorii Zinoviev, insisted that "we must introduce into proletarian art more proletarian simplicity."[9] However, the crucial reason that the state decided not to choose avant-garde art as the official style of Soviet art was that Bolshevik leaders were not confident that they could place it under absolute ideological control. Figures like Malevich regarded themselves as demiurges, but did not view the Communist Party as such–something that the Soviet government would not tolerate.

Avant-garde artists responded differently to the state's suppression of their movement and the announcement of Socialist Realism as the only acceptable art form. Some painters refused to cooperate with the regime and stopped participating in exhibitions altogether. For example, Robert Falk, who returned to the Soviet Union from Paris in 1937 (he had been living there since 1928), refrained from taking part in exhibitions and involved himself in teaching instead. Falk, along with many other left artists, saw his oeuvre within the context of Socialist Realism. In spite of their own difficulties with the regime, these artists genuinely believed that it was only under Communism that an individual could enjoy the necessary freedom and potential for creative development. In contrast, many of Falk's disciples later adopted the "nonconformist" philosophy, attempting to oppose Socialist Realism in part through continuing the traditions of the expiring revolutionary avant-garde.

But the majority of Soviet painters, among them Piotr Konchalovsky, Aristarkh Lentulov and Ilya Mashkov,[10] found themselves adjusting to the state's cultural strictures, more or less adapting their work to the norms of Socialist Realism. Some, like Malevich, who died in 1935, did not live long enough to witness the great wave of Stalinist repression, while others, such as Vasilii Kandinsky and Marc Chagall, had managed to leave the country one or more decades earlier. After a while, the names of the émigrés along with those of other avant-garde artists who remained were expunged from the history of Soviet art—for many decades, they simply ceased to exist.[11]

In spite of the avant-garde artists' hard-fought efforts, it was AKhRR (Association of Artists of Revolutionary Russia; 1922–32) and not the avant-garde that was able to claim the mantle of official Soviet art. For the type of art desired by the state—one that was realist, popularly accessible, and would convey a positive message about Soviet society[12]—the critical realism of the nineteenth-century Itinerant movement was deemed an exemplary source. AKhRR was founded in response to the 47th Itinerant exhibition, held in February 1922.[13] Like their Itinerant predecessors, AKhRR artists focused on contemporary subject matter

[9] Grigorii Zinoviev, as quoted in Golomshtok, *Totalitarian Art*, 38.

[10] These three artists had all been members of the important avant-garde association the Jack of Diamonds.

[11] Many of these artists were later "rehabilitated", permitted to "reenter" Soviet art history under the liberalizing policies of the Khrushchev thaw.

[12] In 1920, Lenin stated: "What art gives to a couple of hundred individuals is not important... art belongs to the people." As quoted in Clara Zetkin, *Reminiscences of Lenin* (Moscow, 1995), 14.

[13] AKhRR was co-founded by Evgenii Katsman. After the passage in his diary quoted above, Katsman recounted: "AKhRR was developing fast, and hundreds of thousands of people started visiting its exhibitions, devoted to the everyday life of the workers, the everyday life of the nations of the USSR and the Red Army." As quoted in Khvostenko, *Vechera na Maslovke bliz Dinamo*, 162.

and embraced the notion of a social-educational role for art. However, while the Itinerants often used their work to address social and economic inequities existing among the various strata of Russian society,[14] the members of AKhRR dedicated themselves to reflecting the views of the Party and contributing to the cause of the working class, doing so in a style they termed "heroic realism."[15] As AKhRR explained in its 1922 "Declaration:"

> *Our civil duty is to accurately portray for humanity the greatest*
> *moment in history in its revolutionary upsurge. We will document*
> *the present: the everyday life of the Red Army, of the workers, peas-*
> *ants, revolutionaries, and heroes of the labor front. We will show*
> *the true picture of reality, not some abstract notions that discredit*
> *our Revolution in the eyes of the world proletariat.*[16]

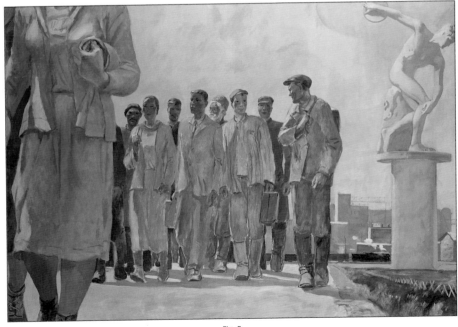

Fig. 5
Study for a Mural, 1930s
Aleksandr A. Deineka

The AKhRR program included all the main elements of the style that would dominate Soviet art for years to come. Shortly after the appearance of its manifesto, AKhRR wrote a letter to the Central Committee asking for guidance concerning its work. That same year, the Party indicated a new objective for Soviet artists: "Back to the Itinerants."

AKhRR's triumph over other competing aesthetic tendencies was only a matter of time. Given the complete absence of a market economy in the Soviet Union, the material support of the government alone could guarantee the survival of any artistic association. The government's awarding of various privileges and official commissions to AKhRR artists, its purchase of paintings by the group's members, and its sponsorship of AKhRR exhibitions led to a situation in which AKhRR's "heroic realism" emerged as the only official art.

A romanticized approach to subject matter is characteristic of much Soviet art of the late 1920s and early 1930s. Artists affiliated with OST (Society of Easel Painters; 1925–32), which sought to merge the avant-garde idiom with figural representation,[17] were among the leading representatives of this tendency. One of the best-known members of OST was Aleksandr Deineka. Deineka's favorite subjects were sports events and collective images of the new Soviet people. Both are treated in *Study for a Mural* (Fig. 5). Picturing a procession of joyful and determined citizens walking down the street, *Study for a Mural* functions as an allegory of the victory of Communism–the laborious road travelled by ordinary Soviet people leading them to the promised radiant future. This work also features a statue of a discus-thrower: a symbol of the New Man, perfect in every respect.

[14] The Itinerant movement of the 1870s–1880s has often been linked to the Russian radical social experiments of the time, most notably the Populist movement of the 1860s and 1870s, which was dedicated to agrarian reform and the liberation of the peasantry.

[15] The principal basis for the new aesthetics was Lenin's article "Party Organization and Party Literature" (1905).

[16] "Declaration" of AKhRR (May 1922), as reprinted in A. V. Grigoriev, E. Katsman, and P. A. Radimov, eds., *Four Years of AKhRR, 1922–26; Collection of Essays*, vol. 1 (Moscow: AKhRR, 1926).

[17] After AKhRR, OST was the second most important artistic grouping of the period.

opened a special exhibition space for their work.

Many official artists of this period responded to the ebbing of Soviet utopianism by retreating into a world of intellectual self-perfection, embracing private imagery and turning to the great painting schools of the past, particularly that of the Italian Renaissance. Aleksandr Romanychev's *By the Window* (Fig. 10) is characteristic of this stage in the development of Soviet art. The painting depicts a young pregnant woman sewing diapers for her soon-to-be-arriving baby. Behind her we can see the numerous windows of an adjacent apartment building whose inhabitants live their separate, discreet lives. The composition and narrative subject of *By the Window* were clearly inspired by works of the Renaissance–in this context, the woman pictured becomes an allegory of the Virgin Mary. The painting also suggests an enormously enlarged clipped photograph. By cropping the edges of the picture, the artist was able to create the impression that the image could not be fitted within the frame. The freeze-frame effect imbues the work with the character of a sign, a symbol of the purity and goodness of motherhood.

After 1986, when Gorbachev launched his liberalizing reforms, Soviet art ceased to exist as a distinctive style. The boundaries between official and unofficial art vanished, the market began to play an increasing role, galleries and art critics appeared, and post-Soviet art became an integral part of the international artistic landscape. In 1991, the same year that saw the dissolution of the Soviet Union, Geli Korzhev created *Skeleton of Old Relatives* (Plate 10). *Skeleton of Old Relatives* is part of a series of about forty works produced for an exhibition at the Regina Gallery in Moscow. An essay on modern reality and human frailties, the series is populated by grotesque mutant figures termed *turlichi* (the artist's invented nonsensical name for them), envisaged as the next stage of mankind.

Soviet art of the twentieth century as the final avant-garde project is now a phenomenon of the past. However, human values such as love and hatred, hope for the future, and fear of the unexpected are just as important now as they were then. What others witnessed with their own eyes has since become history to us, and to adequately comprehend this heritage we need to look at the works of art themselves, because only there, as the French critic and poet Max Jacob wrote, rather than in any comparison with reality, lies the subject of art and the basis for its veneration.

Ms. Bulanova is an art historian, curator and State Tretyakov Gallery consultant. She lives in Moscow.

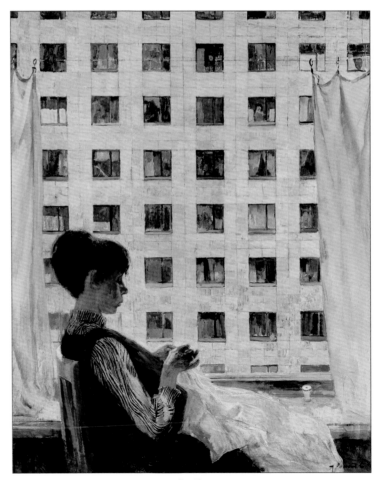

Fig. 10
By the Window, 1968-71
Aleksandr D. Romanychev

Soviet Nonconformist Art:
Its Social and Political Context

by Alla Rosenfeld, Ph.D.

The exhibition *Soviet Dis-Union: Nonconformist and Socialist Realist Art* features a selection of works from the Jane Voorhees Zimmerli Museum's Norton and Nancy Dodge Collection of Nonconformist Art from the Soviet Union. The Dodge Collection, comprising more than twenty thousand works by over two thousand artists, is the largest, most comprehensive collection of its kind in the world. It provides scholars and the general public with a visual record of an era of vast historical significance, one that began in the late 1950s with the start of the Khrushchev thaw and concluded in the mid-1980s, the years of Gorbachev's liberalizing policies of *perestroika* and *glasnost*. The nonconformist movement encompassed a range of artists who, although employing a great variety of styles and practices, were united in both their rejection of the state-prescribed style of Socialist Realism and their search for the means of artistic self-expression. It has often been referred to as the "second culture," or "other culture," in order to distinguish it from official Soviet art of the period.

Most official Soviet art was designed to advance the political goals of the Communist Party. Rendered in a manner that was realistic and easily accessible to the nation's broad masses, Socialist Realism was charged with advancing a clear utopian message: the concept of the glorious Communist future as realized in the Soviet present. Along with the transmission of certain sociopolitical content, the principles of Socialist Realism were applied to all areas of Soviet artistic culture.[1] They permeated the nation's system of art education and served as a guide for the thematic formulation of exhibitions.[2] They determined the

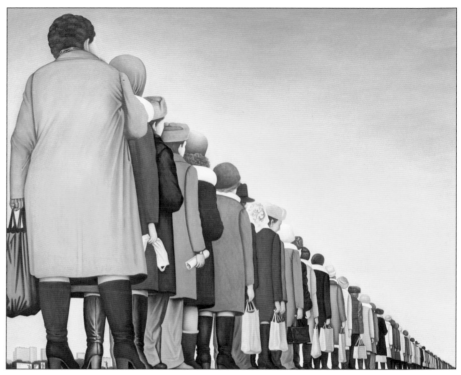

Fig. 10a
Line, 1986
Aleksei Sundukov

subjects and orientation of official arts-related publications—as well as provided the foundation for the state's censorship thereof. In fact, it was on the basis of Socialist Realist doctrine that Soviet authorities identified the types of art they deemed unacceptable. Such work, regarded as antithetical to the goals of Socialist Realism, was not only condemned but suppressed—prohibited from official Soviet art exhibitions and, in many cases, hidden from public view for a number

[1] Among the various organizations that supervised Soviet artistic culture, the Union of Artists of the USSR, or Artists' Union, played the most significant role in the daily lives of the nation's artists. Its activities included dispensing state commissions, recommending purchases of artworks, and assisting in the organization of exhibitions. Also of great importance was the Ministry of Culture of the USSR, whose responsibilities included overseeing the activities of leading Soviet art institutions and managing the art publishing houses.

[2] For an in-depth discussion of the government's control over the arts, see Elena Kornetchuk, "Soviet Art under Governmental Control: From the 1917 Revolution to Khrushchev's Thaw," in Alla Rosenfeld and Norton T. Dodge, eds., *From Gulag to Glasnost: Nonconformist Art from the Soviet Union* (New York: Thames and Hudson; New Brunswick, N.J.: Jane Voorhees Zimmerli Art Museum, 1995), 36-48.

of decades. The state cited four main categories of forbidden art: art imbued with anti-Soviet commentary (Fig. 10a), religious art, erotic art, and so-called "formalist art" (Illus. 1, a satirical illustration from F. P. Reshetnikov's book *Tainy abstraktsionizma*, 1963).

An overarching term that appeared in Soviet art publications as early as the late 1920s, when any type of experimental art began to be perceived as too individualistic, too separated from the masses, and thus fundamentally bourgeois rather than proletarian, formalism was understood as the tendency to ascribe importance to the formal properties of a work of art over and above its subject matter.[3] It was often used in relation to modernist styles and movements, in particular Impressionism, Cubism, Futurism, Dada, Surrealism and Constructivism.[4] The *Concise Dictionary of Art Terms* (Moscow, 1965) asserted that the fight against formalist art was a primary goal of Soviet art.[5]

Why was combating formalism considered of such high importance? The *Concise Dictionary of Art Terms* defined formalism as consisting of "reactionary

trends in art and aesthetics connected with the ideology of decaying capitalism."[6] Artists classified as formalists, particularly those associated with the European and Russian movements just cited, were perceived as practitioners of styles equated with corruption and decadence–in other words, class enemies, purveyors of an anti-Soviet worldview. Vladimir Kemenov, the Soviet official art critic and best-known spokesperson for Socialist Realism, characterized the perceived dangers of formalism as follows:

> *A formalist uses all possible means to distort the pure image of the Soviet people who are engaged in building Communism. A formalist deforms, distorts the face....conducts a horrible dissection of the face and the body of the human being. This program of militating ugliness is clearly an insult to people, and in our society–an insult to the Soviet people, builders of Communism.*[7]

In his 1964 book *The Art of a Decaying Capitalist World*, the art critic Dmitrii Moldavsky described Western modernism as "the art of the decaying capitalist world, the world that tries to sow its poisonous seeds into the consciousness of the Soviet people."[8]

The state's campaign against formalism, which lasted from the early 1930s through the 1970s, provides a useful context for a consideration of Soviet unofficial art. For one thing, a number of modernist art trends and practices that

Illus. 1
Caricature by F.P. Reshetnikov, from F.P. Reshetnikov's book, *Tainy abstraktsionizma (Mysteries of Abstract Art),* (Moscow:*Izdatel'stvo Akademii khudozhestv SSSR, 1963)*

[3] See Matthew Cullerne Bown, *Socialist Realist Painting* (New Haven and London: Yale University Press, 1998), 189.

[4] All were cited as examples of reactionary formalist art in the *Kratkii slovar' terminov izobrazitel'nogo iskusstva* (Concise Dictionary of Art Terms) (Moscow: Sovetskii khudozhnik, 1965), 177.

[5] Ibid., 178.

[6] Ibid., 177.

[7] Vladimir Kemenov, "Reaktsionnye ustremleniia pod flagom 'novatorstva,'" in Vladimir Kemenov, *Protiv abstraktsionizma. V sporakh o realizme* (Leningrad: Khudozhnik RSFSR, 1963), 154.

[8] Dmitrii Moldavsky, *Iskusstvo obrechennogo mira* (Leningrad: Khudozhnik RSFSR, 1964), 76.

fell under the rubric of formalism and were therefore prohibited by the Soviet authorities–Cubism, Expressionism, Surrealism, abstraction, Pop Art–informed the work of Soviet nonconformist artists. For another, some of the same critiques lodged against formalist art would also be directed against unofficial art. While the pluralistic nature of the nonconformist art scene of the 1960s to the 1980s may strike Western observers as merely Soviet artists' belated attempt to quickly absorb styles that had emerged in Western Europe and the United States decades earlier, it is important to realize that in the Soviet Union any deviation from the norms of Socialist Realism constituted an exceptional act of courage, a deed signifying the rejection of official authority. The creation of work that did not adhere to Soviet state ideology meant jeopardizing one's livelihood and safety. For many Soviet nonconformist artists, it resulted in loss of employment, arrest or placement in a psychiatric institution.

The history of Soviet unofficial art could be divided into three periods. The first, roughly identifiable with the years of the Khrushchev thaw, began in the mid-1950s amid the cultural and political developments that unfolded in the aftermath of Stalin's death in March 1953 and concluded with the events surrounding the 1962 exhibition *Thirty Years of MOSKh (Moscow Section of the Union of Artists)*.[9] The thaw was ushered in by Khrushchev's 1956 Secret Speech at the Twentieth Congress of the Communist Party, in which he revealed and denounced Stalin's crimes against the Soviet people and the Party.[10] The Secret Speech launched Khrushchev's de-Stalinization campaign, signaling the regime's wish to distance itself from the horrors of the recent past. Around this time, the state also began to relax its tight control over artistic culture. These and other related developments inspired a great sense of optimism on the part of the Soviet literary and artistic intelligentsia–an optimism that for a brief period seemed justified.

The first sign of change in the visual arts occurred only two months after Stalin's death when, departing from a decades-long tradition, the journal *Iskusstvo*

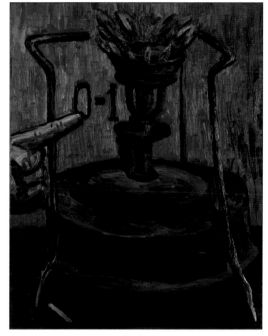

Fig. 11
Primus 0.1, 1965
Mikhail Roginsky

(Art) failed to publish a single reproduction of any artwork depicting the recently deceased ruler. This was followed that same year by the reinstatement of the Pushkin Museum of Fine Art's original mission: the display of Western European art. In 1949, the museum's outstanding holdings of European art had been frozen to make way for a permanent exhibition of gifts to Stalin on the occasion of the ruler's seventieth birthday.

The changeover at the Pushkin Museum was symptomatic of one of the most dramatic cultural aspects of the thaw: Khrushchev's reopening of the channels to Western intellectual and artistic life. For the first time in more than twenty-five years, Soviet artists were exposed to contemporary artistic developments in the West. Information on recent Western art could now be gleaned from Western art journals, newly available at some of the nation's major libraries, while the art itself could be seen in the large, important exhibi-

[9] See Vladimir Yankilevsky, "Memoirs of the Manezh Exhibition, 1962," *Zimmerli Journal* 1 (Fall 2003), ed. Phillip Dennis Cate and Jane A. Sharp (Part 1 Editor): 67-77.

[10] Khrushchev's speech was delivered on February 25-26, 1956. The term "thaw," used to describe the lifting of cultural restrictions during the late 1950s and early 1960s, derives from the title of Ilya Ehrenburg's 1954 novel, *The Thaw*. One of *The Thaw*'s protagonists, Saburov, was perceived at that time as an opponent of Party ideology. For a discussion of the period, see Michael Scammell, "Art as Politics and Politics in Art," in Rosenfeld and Dodge, eds., *From Gulag to Glasnost*, 49-51.

[11] During the 1950s and early 1960s, the following exhibitions of Western art were held at the Hermitage: *The Art of Belgium and Holland, 18th–20th Centuries* (1954); *Finnish Art of the 19th and 20th Centuries* (1955); *French Art, 17th–20th Centuries* (1956); *The Art of Scandinavia* (1956); *British Art, 16th– 20th Centuries* (1956); *Paul Cézanne* (1956); *Contemporary Italian Drawing* (1956); *The Art of Belgium, 19th–20th Centuries* (1956); and *The Contemporary Graphic Arts of Argentina* (1958).

tions held in Moscow and Leningrad around that time.[11] In 1956, a major Picasso exhibition was presented at the Pushkin Museum in Moscow that later traveled to the Hermitage Museum in Leningrad. In the summer of 1957, an exhibition containing more than 4,500 works by artists representing various cultural and stylistic traditions and hailing from fifty-two countries was included as part of the Sixth World Festival of Youth and Students held in Moscow's Sokolniki Park.

Two years later, the exhibition *American Painting and Sculpture*, which formed part of the *American National Exhibition* held in Moscow from July 25 through September 5, caused a great stir among the nation's artists and art-viewing public.[12] The depictions of simple interiors and scenes of everyday life by such artists as Edward Hopper, Ben Shahn and Rafael Soyer, included in *American Painting and Sculpture*, had a lasting impression on Mikhail Roginsky, who came to be one of Moscow's leading nonconformist artists. During the 1960s, Roginsky's preferred subject matter consisted of the most mundane household items. He devoted an entire series of paintings to the primus stove, a once-common Russian cooking device (Fig. 11). In 1965, Roginsky created paintings of tiled floors, doors and walls, to which he often attached real objects such as handles, electrical outlets and plugs (Plate 70).

Along with gaining access to Western cultural developments, Soviet artists during the thaw were also re-introduced to a long-forbidden aspect of their own artistic heritage: the early-twentieth-century Russian avant-garde. A number of

public exhibitions of this work–much of which had languished for years in museum storage facilities–were mounted during the 1960s.[13] Avant-garde art could now also be studied in private collections, such as the one assembled by George Costakis.[14] The artist Francisco Infante-Arana (Plates 51-53), has described how, beginning in the late 1960s, he was deeply affected by his repeated visits to the Costakis collection, in particular by his encounters with the work of Aleksandr Rodchenko and Kazimir Malevich. In addition, Soviet artists of the period were able to see the work of the leading Russian avant-garde artist Robert Falk (who died

Fig. 12
Poet Vsevolod Nekrasov, 1981-85
Eric Bulatov

in 1958) in the weekly studio viewings organized by his widow around this time, viewings that were attended by some future nonconformist artists, including Eric Bulatov, whose *Poet Vsevolod Nekrasov* is included in this exhibition (Fig. 12). Equally important, surviving experimental artists (most notably, Vladimir Favorsky) served as teachers to the new generation of Soviet artists, many of whom came to be associated with the unofficial art movement.

[12] The *American National Exhibition* was the most ambitious project of the period to implement the East-West cultural exchange agreement signed by the United States and the Soviet Union in 1958. It was organized by the USIA (United States Information Agency), which appointed a selection committee approved by President Eisenhower that comprised Lloyd Goodrich (Director of the Whitney Museum of American Art), Henry Hope (Chairman of the Fine Arts Department at Indiana University and editor of *College Art Journal*), Franklin Watkins (an instructor of painting at the Pennsylvania Academy of the Fine Arts in Philadelphia), and Theodore Roszak (a Polish-born American sculptor). Featuring twenty-three sculptures and forty-nine paintings, the exhibition represented the broad scope of art created in the U.S. from 1918 to 1959, ranging from the work of the early New York realists and American scene painters to Abstract Expressionism. (See Lloyd Goodrich, Introduction, *Painting and Sculpture from the American National Exhibition in Moscow* [New York: Whitney Museum of American Art, 1959] [exh. cat.], 2-8.) Among the other important exhibitions of American art shown in Russia around that time were *Graphic Arts USA* (Alma-Ata, Kazakhstan; Moscow; Yerevan, Armenia; and Leningrad; 1963-64); *Architecture USA* (Leningrad; Minsk, Belarus; and Moscow; 1965); and *Industrial Design USA* (Moscow; Kiev, Ukraine; and Leningrad; 1967). In 1959, the Pushkin Museum of Fine Arts organized an exhibition of work by American artists of the eighteenth through the twentieth centuries from the collections of Soviet museums.

[13] In 1960, an El Lissitzky exhibition was organized at the State Mayakovsky Museum in Moscow. The same museum held exhibitions devoted to the work of Mikhail Matiushin, Pavel Filonov and Gustav Klutsis in 1961, and to work by Vladimir Tatlin and Kazimir Malevich the following year. The organizers of these exhibitions were Nikolai Khardzhiev and Gennadii Aigi (from 1961). In Leningrad, LOSKh (Leningrad Section of the Artists' Union) was the site of a 1965 exhibition dedicated to the work of Vladimir Sterligov, a former student of Malevich, and Tatiana Glebova, who had been associated with the Filonov School. An exhibition of works by Pavel Filonov himself was held the following year, although it was closed down by the authorities after only one day.

[14] Matthew Cullerne Bown, *Art Under Stalin* (Oxford: Phaidon Press, 1991), 183.

The partial liberalization of society initiated by Khrushchev helped unleash the concealed creative potential of a number of Soviet artists, prompting many to produce works of their own that challenged the tenets of Socialist Realism. At the same time, artists had to pursue alternative types of venues at which to display these works: private apartments and a range of public spaces, including clubs, scientific-research institutes, cafés, and lobbies of movie theaters.[15] The many exhibitions of the experimental art now being created were of great interest to Soviet citizens. Usually of very brief duration due to the countermeasures of the authorities (some shows lasted only a few days or a few hours), these exhibitions often attracted enormous numbers of viewers, despite the associated risks of persecution for those who attended. The exhibition organizers themselves also faced serious consequences for their actions, including the possible loss of employment.[16] Among the organizers of such exhibitions were noted scientists (Piotr Kapitsa), musicians and composers (Sviatoslav Richter and Andrei Volkonsky), and private collectors who had first made their appearance during those years (Costakis, Alexander Glezer, Yevgeny Nutovich and Leonid Talochkin).

The first groupings of nonconformist artists emerged around this time, that of the mid-to late 1950s and early 1960s. They included the Lianozovo Group,

Fig. 13
Untitled, n.d.
Aleksandr Arefiev

whose members were united by the search for a new socio-cultural identity based on freedom of artistic expression and who met once or twice a week to paint or draw, read poems and discuss contemporary art.[17] The informal leader of the group was Oscar Rabin. Although remaining a realist, Rabin was influenced by some of the Western modernist art he encountered in Moscow exhibitions between 1957 and 1962, and thereafter began painting in an expressionist mode. Instead of idealized images of Soviet prosperity, Rabin painted pictures of suburban slums, desolate streets, and the local railroad station. His still lifes treat subjects like smoked herring and a tumbler of vodka placed atop a torn copy of the Soviet official newspaper *Pravda* (plate 68). As the scholar Michael Scammell has observed, such imagery represented Rabin's commentary not only on the daily meal of the average Soviet working-class man, but also on the use the artist had for the Party newspaper.[18] In 1978, Rabin was stripped of his Soviet citizenship and deported.[19]

In Leningrad, Arefiev Circle artists were among the first to reject the false joyfulness of the Stalin era.[20] Turning to those located at the margins of Soviet

[15] In 1962, the year of the Manezh exhibition, at least two exhibitions of unofficial art were held on academic premises in Moscow. By 1965, other nonconformist art exhibitions in Moscow were presented at the prestigious Kurchatov Institute of Atomic Physics, the Physics Institute, the Institute of Biochemistry, and the Institute of Hygiene and Occupational Health.

[16] For example, one such exhibition, organized by Alexander Glezer in January 1967 in the House of Culture *Druzhba* on the Shosse Entuziastov in Moscow, was closed down because it contained abstract and surrealist works. The director of the house of culture was removed from his job and pressure was placed on the participating artists, who were warned not to repeat such actions in the future.

[17] The members of the Lianozovo Group, named for an area located on the outskirts of Moscow, included Rabin, Olga Potapova, Lev Kropivnitsky, Valentina Kropivnitskaia, Lydia Masterkova, Vladimir Nemukhin, and Nikolai Vechtomov. Several poets were also associated with the group, including Igor Kholin, Genrikh Sapgirr, and Vladimir Nekrasov. On Lianozovo, see Yevgeny Barabanov, "Lianozovskoe sodruzhestvo," in Ekaterina Dyogot and Victor Misiano, eds., *Moskau-Berlin/Berlin-Moskau, 1950-2000* (Moscow: Trilistnik, 2004) [exh. cat.], 48-50.

[18] See Scammell, "Art as Politics and Politics in Art," in Rosenfeld and Dodge, eds., *From Gulag to Glasnost*, 58.

[19] Rabin has since settled in Paris.

[20] On the Arefiev Circle, see Liubov Gurevich, *Arefievskii krug* (St. Petersburg: P.R.P., 2002). Also see Irina Karasik, "'Our Painting Is the Only Cry of Life': Aleksandr Arefiev and the Portrayal of the Soviet Urban Underclass," *Zimmerli Journal* 2 (Fall 2004), ed. Phillip Dennis Cate and Alla Rosenfeld (Part 1 Editor): 66-73. [21] Andrei Lebedev, *Protiv abstraktsionizma v iskusstve* (Moscow: Izdatel'stvo Akademii khudozhestv SSSR, 1961), 16.

society and to the banal, dreary aspects of everyday Soviet life, they depicted street fights, incidents of police brutality, and garbage dumps, creating works that constituted the very antithesis of Socialist Realism and its idealized vision of Soviet existence. An excellent example is Aleksandr Arefiev's *Untitled*, n.d. (Fig. 13). The group was centered around this artist whose raw and gritty subject matter was rendered in a realist style that was both candid and confrontational, as seen in *Untitled, 1955* (Plate 39).

Another important area within nonconformist art, particularly during the early 1960s, was abstraction. Seen as the very antithesis of content-centered Socialist Realism, abstract art was perhaps the most hated of all Western and Russian modernist movements. While its practitioners were primarily concerned with aesthetics rather than politics, their works were quickly politicized by the state. In his 1961 book *Against Abstraction in Art*, Andrei Lebedev, Deputy Head of the Art Department of the Art Committee and the dominant critic-member of the Academy of Arts, argued:

> *Abstract art is used by the bourgeoisie...to distract the masses from the class struggle and to paralyze their will to fight for the triumph of Socialism....Abstract art leads the artist and viewer away from life....It cannot tell the tale of the bloody wars, exploitation and national discrimination, unemployment and poverty....Many artists turn to abstraction in an attempt to escape the major problems and conflicts of life in contemporary society.*[21]

The conclusion of the book contained what was perhaps Lebedev's most stinging indictment of abstraction: "Abstract art is directed against the human being and against social progress".[22]

This exhibition includes a number of works by nonconformist artists who

Fig. 14
Composition, 1961
Vladimir Nemukhin

employed a wide variety of abstract styles. Two examples are Oleg Prokofiev's *The Window* (Plate 67) and Boris Turetsky's *Untitled, 1958* (Plate 75). While Vladimir Nemukhin's work, *Composition* (Fig. 14), reflects the influence of the American Abstract Expressionists, some of whose paintings he viewed at the Sixth World Festival of Youth and Students, that of Leonid Borisov evokes the Russian avant-garde movement of the 1920s through its simplicity, exploration of spatial relationships, and deployment of basic geometric forms, as seen in *Composition*, created in 1977 (Plate 42).

The period of seeming reciprocal openness between the Soviet government and the artistic intelligentsia that characterized the thaw years was brief. It ended with Khrushchev's December 1 visit to the 1962 Manezh exhibition. In conjunction with *Thirty Years of MOSKh*, an ancillary exhibition of experimental artworks was mounted on the second floor of the Manezh Central Exhibition Hall. The artist Vladimir Yankilevsky, who by 1961 had begun to produce mixed media works that combine painting and relief in a triptych format (Plate 78), was

[21] Andrei Lebedev, Protiv abstraktsionizma v iskusstve (Moscow: Izdatel'stvo Akademii khudozhestv SSSR, 1961), 16.

[22] Ibid

among the select few invited to present their work in this ancillary show. During Khrushchev's visit, an argument broke out between the Soviet Premier and the experimental sculptor Ernst Neizvestny on the function of art and the best means of reflecting reality. The upshot of the heated exchange was that the works of the experimental artists on view upstairs were declared formalistic, under the influence of bourgeois ideology, and harmful and alien to the Soviet people. This incident, which entered history as the "Manezh Affair," prompted an intense government-orchestrated backlash against any deviation from the norms of Socialist Realism that affected not only the visual arts but extended to other areas of culture as well. Conservative politicians capitalized on the Manezh scandal to halt efforts to modify the artistic canon underway at that time, and to revive and strengthen the mechanisms of control that had apparently been weakened amid the initial euphoria of the thaw.

The state's campaign against formalism and ideological deviation initiated in late 1962 and early 1963 ushered in a new phase in the evolution of Soviet nonconformist art. Throughout 1963, censorship was again tightened. In the fall of 1965, a typescript of *The First Circle* and other unpublished works by Alexander Solzhenitsyn were confiscated during a KGB raid. That same year, two other writers, Andrei Siniavsky and Yulii Daniel, were accused of publishing their stories in the West.[23] They were subsequently arrested, tried, and sentenced to terms in the labor camps. During their 1966 public trial, both men were not only unapologetic about their "crimes," they refused to acknowledge any guilt whatsoever. In their final statement at the trial, Siniavsky and Daniel asserted artistic freedom and the artist's right to self-expression. While clearly intended to demonstrate to the Soviet artistic intelligentsia that there would be severe consequences for those not conforming to official policy in the arts, the Siniavsky-Daniel trial had an enormous impact on the emergence of the Soviet dissident

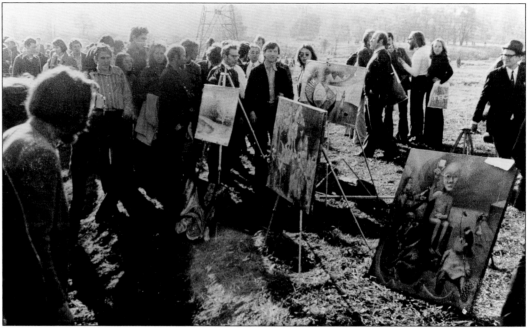

Illus. 2
Second Fall Open-Air Show of Paintings
Izmailovsky Park, Moscow, Sept. 29, 1974
Dodge Collection Archive, photograph by Grigorii Verhovsky

movement. It spurred large protests amid the nonconformist art community over the fate of the two writers and the larger issue of censorship.[24] Further arrests and trials only fanned the flames of protest. In the aftermath of the trial, a clear schism was now evident in Soviet literature and art, which from that point on was divided into two opposing branches—official (public) and unofficial (private).

The third phase in the development of Soviet nonconformist art lasted from approximately the mid-1970s to 1988. The 1973 trials of Petr Yakir and Victor

[23] Andrei Siniavsky worked in the Soviet literature department of the Institute of World Literature in Moscow. He also taught at Moscow State University and published his essays in the most progressive journal of the period, *Novyi mir*. Starting in the mid-1950s, Siniavsky began publishing in the West under the name Abram Tertz. In 1960, Siniavsky, in collaboration with Igor Golomshtok, published a book on Picasso that, according to Vladimir Kemenov, dealt "a serious blow to the task of the fight for realist art." (See Vladimir Kemenov, "Nekotorye voprosy sviazi iskusstva s zhizn'iu," in idem, *Protiv abstraktsionizma*, 114.) Siniavsky was sentenced to seven years in the labor camps. After his release from prison, he immigrated to France. Yulii Daniel, who wrote poetry, published his literary works in the West under the name Nikolai Arzhak. He was sentenced to five years in prison.

[24] On December 5, 1965, a demonstration took place in Pushkin Square in Moscow to protest the trial. The date has since been declared the birthday of the nation's human rights movement.

Krasin, two of the leaders of the human rights movements;[25] the stripping of Solzhenitsyn's Soviet citizenship in 1974; and the dismantling of Khrushchev's liberalizing reforms around that same time, combined with the growing self-consciousness of nonconformist artists, prompted unofficial artists to address the issue of the public's access to their work within the framework of Soviet law. On September 15, 1974, Oscar Rabin and his friends organized an exhibition of independent artists on the outskirts of Moscow. In less than an hour, the exhibition was demolished by bulldozers and water trucks sent by the Soviet authorities. These events—which gave rise to the moniker "Bulldozer Exhibition," as the exhibition has since been known—were widely reported in the Western press, inspiring international outrage over human rights violations within the Soviet Union. The fallout from the Bulldozer Exhibition forced the Soviet authorities to allow the unofficial artists to hold an outdoor exhibition in Moscow's Izmailovsky Park on September 29, 1974. (See the documentary photograph from the Dodge Collection archive, Illus. 2.) Featuring one hundred paintings created by approximately sixty-five artists, the Izmailovsky Park exhibition was seen by some ten- to fifteen-thousand people. Other nonconformist exhibitions followed, including the one held at the Beekeeping Pavilion at the All-Union Exhibition of Economic Achievements later that year.[26]

Moved by the fate of the Bulldozer Exhibition, Leningrad dissident artists decided to organize a comparable exhibition of their own works. There thus appeared throughout the city exhibitions of nonconformist artists at various Palaces of Culture.[27] The first major Leningrad exhibition of unofficial art was held at the Gaz Palace of Culture in 1974. Although open only during working hours, from 11 a.m. to 5 p.m., and lasting a mere four days, the Gaz exhibition drew huge crowds—eight thousand visitors—many of whom waited as long as seven hours to view the art on display. The second important Leningrad showing of nonconformist art occurred at the Nevsky Palace of Culture in September 1975. It featured roughly six hundred works by eighty-eight Leningrad and several Moscow artists. The following year, an official exhibition of primarily abstract art was presented at the Ordzhonikidze Palace of Culture. Between 1977 and 1980, Leningrad nonconformist artists organized many apartment showings of their work. The Soviet government regarded such activities as illegal, and subsequently imprisoned or forcibly deported several of their organizers.

Although abstract art emerged early on in the history of the Leningrad nonconformist movement—the late 1950s—figurative art predominated. In 1964, Vladimir Ovchinnikov, one of the unofficial figurative artists, exhibited with Mikhail Chemiakin and others in the ill-fated *Exhibition of Workmen Artists* held in the staff area of the Hermitage Museum. After just three days the exhibition was closed by the KGB, all the works were confiscated, and all the participants, along with the museum director M. I. Artamonov, who had supported the show, were fired.[28] Despite his adherence to academic traditions in his paintings, Ovchinnikov was just as much a *persona non grata* with the authorities as practitioners of abstraction or surrealism because of the ironic, socially critical, and often religious nature of his work, as seen in *Banishment of the Money Changers in the Temple* (Fig. 15).

[25] Petr Yakir was one of the most active leaders of the human rights movement in Soviet Russia during the 1960s. In 1969, he became one of the founders of the Initiative Group for Defense of the Human Rights in the USSR. His apartment on Avtozavodskaia Street in Moscow became an important gathering place for dissidents, providing access to many *samizdat* publications. At the end of the 1960s, Yakir also served as a major link with various Western correspondents. In 1972, he was arrested together with Victor Krasin. During their KGB interrogations, both Yakir and Krasin were forced to take part in a television program in which they admitted their (alleged) ideological mistakes. In the 1970s, Yakir's memoirs describing his childhood years in prison became available as a *samizdat* publication. (Yakir was first arrested at the age of fourteen as a son of the enemy of the Soviet people and then went on to spend seventeen years in prisons and labor camps.)

[26] See Yevgeny Barabanov, "The Year of Art: Major Nonconformist Exhibitions of 1974–75," *Zimmerli Journal* 2 (Fall 2004), ed. Phillip Dennis Cate and Alla Rosenfeld (Part 1 Editor): 128–39.

[27] Palaces of Culture were small clubs that had originated in the 1920s as sites for workers' cultural and social edification and were transformed during the 1950s and 1960s into leisure centers, housing cinemas, libraries and amateur societies.

[28] In addition, the KGB tracked down viewers who had written favorable comments in the visitors' book. Many of these individuals lost their jobs as well.

Irony was central to the creative practice of the artists associated with the Sots Art movement, who sought to deconstruct the ideological clichés of everyday Soviet reality and visual culture. Vitaly Komar and Alexander Melamid, who developed Sots Art in the early 1970s, employed the language of the Soviet state in a satiric-critical manner, often incorporating parodies of political posters and Party slogans or comical manipulations of the ubiquitous images of the father figures of Soviet ideology. *Quotation* (Fig. 16) replaces the letters forming various Soviet slogans with rows of white cubes, signifying the omnipresence of all political slogans. However, Komar and Melamid's favorite target was Socialist Realism in all its forms, as evidenced in *Khrushchev's Plot Against Beria* (Fig. 17).

In the works of the Sots Art figures Rostislav Lebedev, Boris Orlov, Aleksandr Kosolapov and Leonid Sokov, stereotypes of Soviet propaganda are transformed into a new, contemporary language, one that represents a parodic inversion of Soviet ideology. In *Baltika* (Plate 57), Kosolapov appropriates elements of Soviet kitsch to satirize Soviet ideological mass production. The *Birth of the Hero* series by Grisha Bruskin (exemplified by Plates 44-48) is a collection of Soviet ideological archetypes and includes religious-mystical, magical characters: angels and demons symbolizing good and evil. Although the series is reminiscent of Soviet park sculpture, the sculpture of monumental propaganda, Bruskin deconstructs the monumental heroic Soviet figures by rendering these icons of authority as expressionless and robot-like.

Along with Sots Art, another important trend in unofficial art of the 1970s was the deployment of an unflinching approach to Soviet reality as a means of protest against the regime. This is seen in the work of the Moscow artist Leonid Lamm who turned to images created during his imprisonment in Butyrka Prison (Plate 59).

Baltic nonconformist artists explored a similar range of modernist styles and practices as their Russian contemporaries. The Lithuanian artist Raimundas

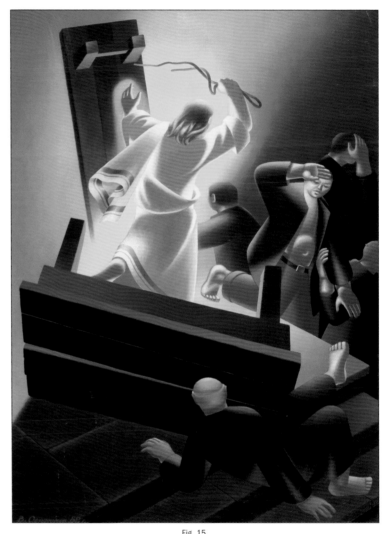

Fig. 15
Banishment of the Money Changers in the Temple, 1982
Vladimir Ovchinnikov

Martinenas created assemblages from found objects, including official portraits of leading figures in the Soviet government which he then manipulated (see *Anonymous History*, Plate 61). Romanas Vilkauskas, one of the most consistent representatives of Lithuanian photorealism, created works with undertones of

Fig. 16
Quotation, n.d.
Vitaly Komar and
Alexander Melamid

the Lithuanian resistance movement and postwar deportations. His views of interiors featuring walls covered with yellowed newspapers containing Stalin's photographs were intended to contest the historical fictions manufactured by Communist Party ideology, as in *Interior X* (Plate 76).[29]

With Mikhail Gobachev's rise to power in March 1985 and his calls for *glasnost* and *perestroika*, the underground movement lost its *raison d'etre*. By that time the boundaries between Soviet official and nonconformist art had already begun to dissolve. Final steps toward the deconstruction of the totalitarian Soviet state occurred between 1989 and 1991, when the former Soviet republics declared their sovereignty. These political developments also had major repercussions for artists in the former Soviet Union, who now finally had the freedom to openly depict formerly forbidden images and to exercise their right to individualized self-expression.

Dr. Rosenfeld is the Director of the Department of Russian Art and Senior Curator of Russian and Soviet Nonconformist Art at the Jane Voorhees Zimmerli Art Museum Rutgers, The State University of New Jersey, New Brunswick, N.J.

Fig. 17
Khrushchev's Plot Against Beria, 1981-82
Vitaly Komar and Alexander Melamid

[29] On the work of Lithuanian artists, see Viktoras Liutkus, "Breaking the Barriers: Art under the Pressure of Soviet Ideology from World War II to Glasnost," in Alla Rosenfeld and Norton T. Dodge, eds., *Art of the Baltics: The Struggle for Freedom of Artistic Expression Under the Soviets, 1945–1991* (New Brunswick, N.J.: Rutgers University Press and the Zimmerli Art Museum, 2002), 303-53.

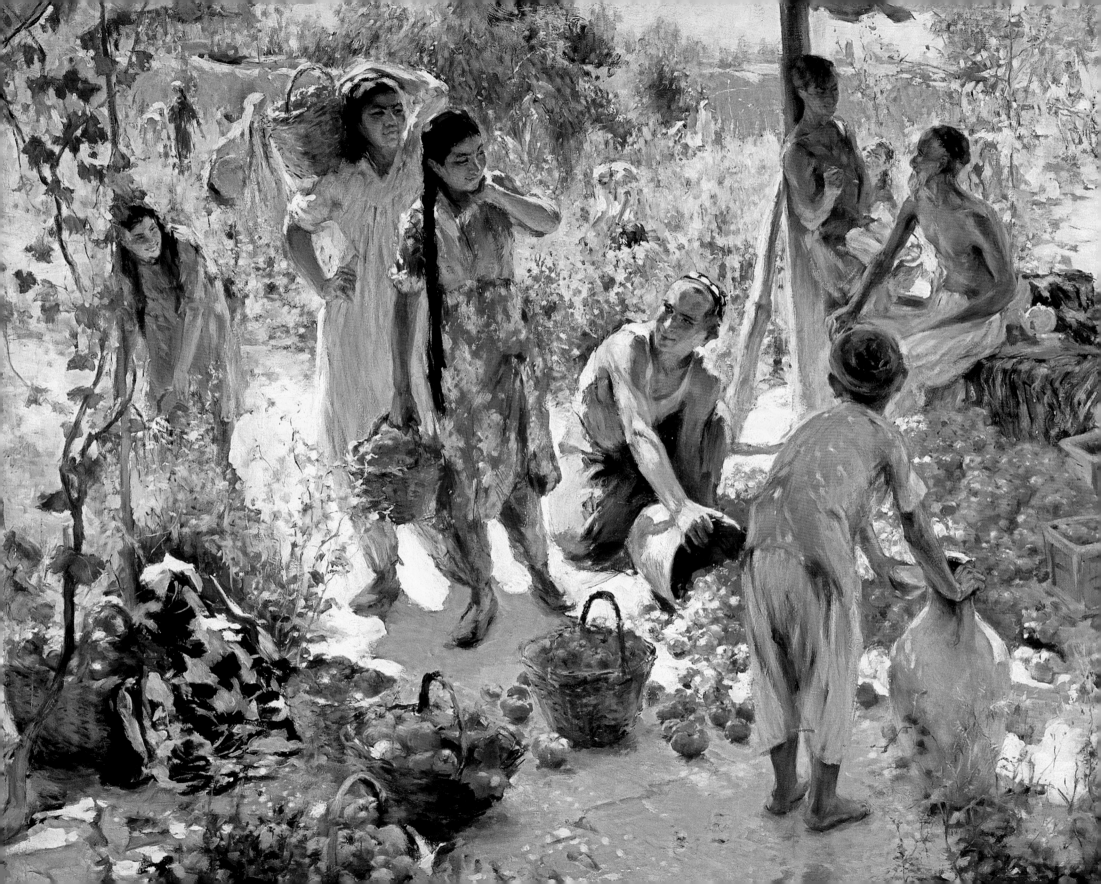

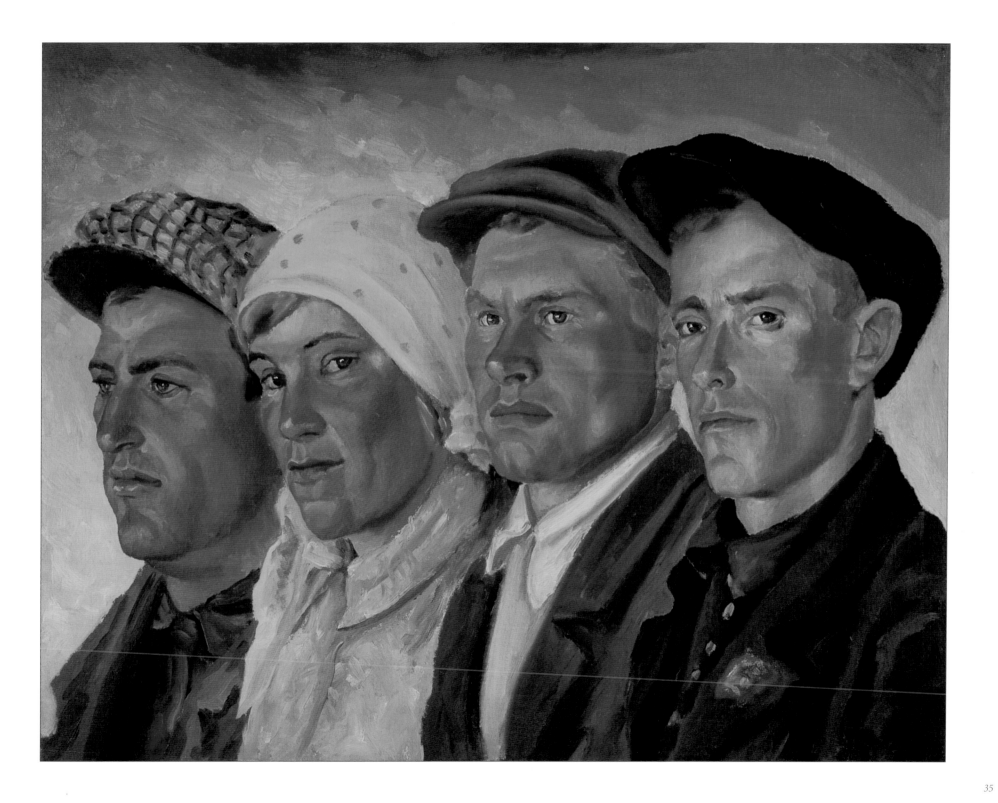

Eduard Georgievich BRAGOVSKY

1923 –

Plate 3

Logging on the Vetluga

1964

Oil on canvas

59 x 79 inches

Bragovsky studied at the Moscow State Art Institute from 1947 to 1953 under V. V. Pochitalov, V. G. Tsyplakov and V. K. Nechitailo.

During the 1960s, the liberalization of Soviet art that ensued in the aftermath of Stalin's death was manifested primarily in a new appreciation of mankind. It was also seen in the revival of modernist aesthetic concerns such as the exploration of decorativeness, flatness of space, the role of color and line in formal structure, and the pursuit of generalization, all of which ushered in a fresh approach to the beauty of nature rediscovered by Russian artists at this time. The present work exemplifies many of these principles, picturing one of Bragovsky's favorite travel destinations: the Vetluga River, a tributary of the Volga.

—⁓—

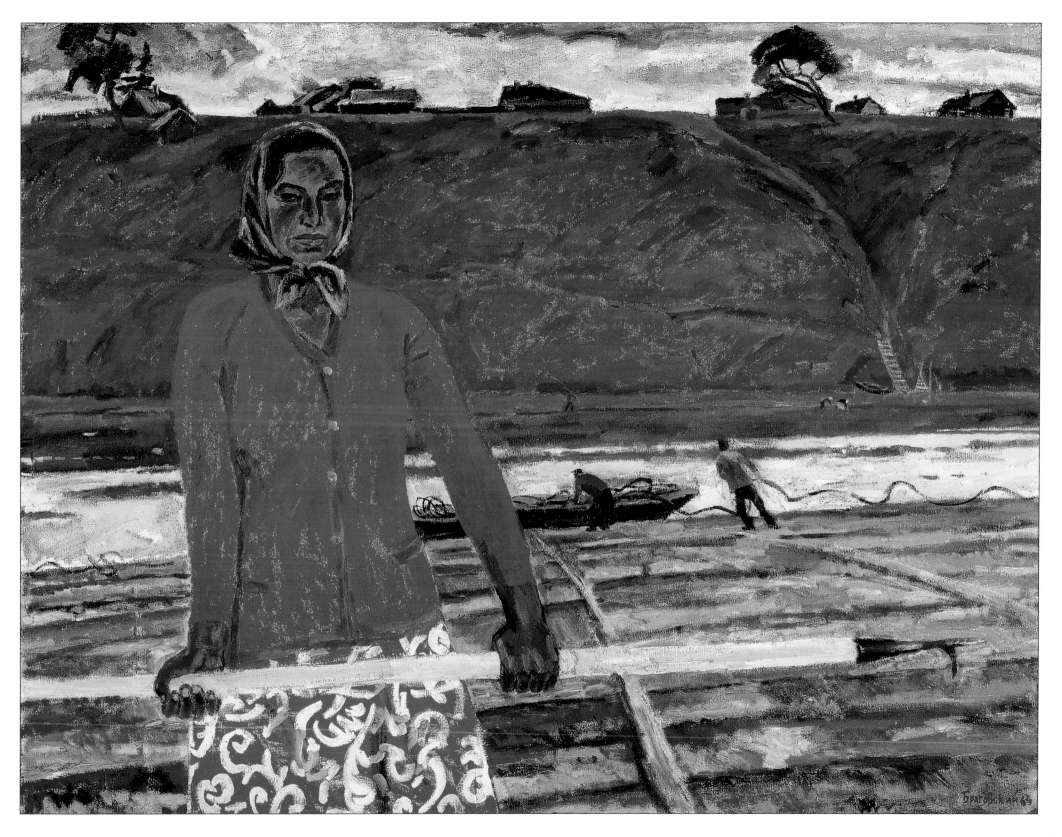

Eric Vladimirovich BULATOV

1933 –

Plate 4

At the Spring

1957

Oil on canvas

50 x 39 inches

From 1952 to 1958, Bulatov took classes at the Surikov Art Institute in Moscow. He also studied in the studios of Robert Falk and Vladimir Favorsky. Mai Dantsig, one of Bulatov's fellow students at the Surikov Institute, shared the following story: One of their professors at the institute was organizing a trip to India for which only A-students were eligible to participate. Those students included Bulatov and himself. Inoculation against smallpox was also required for the journey. Dantsig refused and had to stay in Moscow, while Bulatov agreed to receive the vaccination. One of the results of the trip to India is *At the Spring*, in which Bulatov sought to convey his impressions of the country. It is interesting to note that beginning in the late 1960s Bulatov abandoned the Socialist Realist style and became one of the leaders of the Moscow conceptualist school.

—⁓—

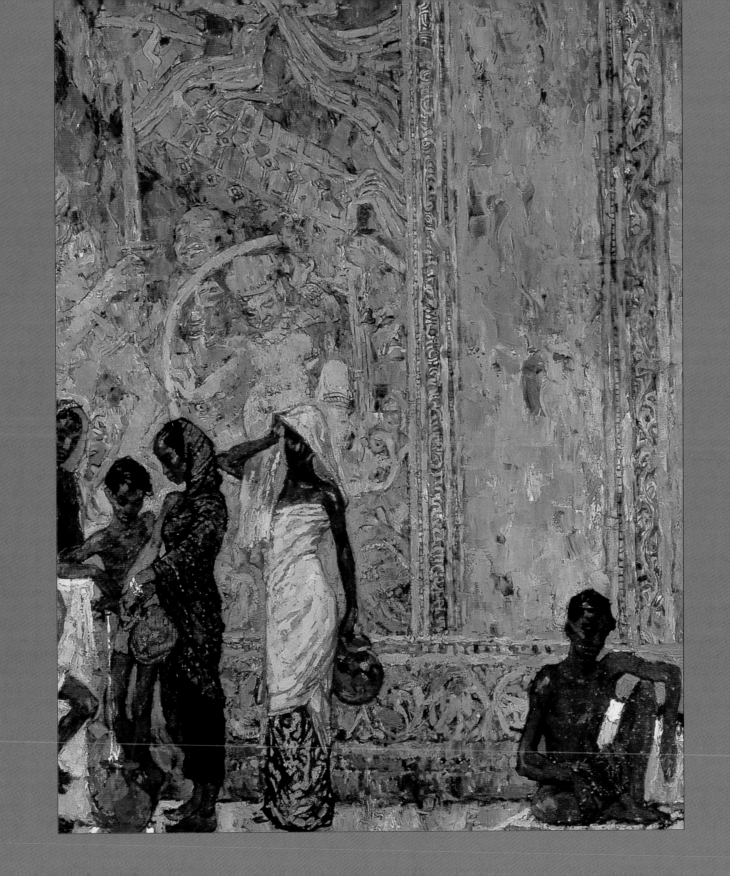

Semon Afanasevich CHUIKOV

1902 – 1980

Plate 5

**A Daughter of
Soviet Kirghizia**

1950

Oil on canvas

47 x 37 inches

From a Private
American Collection.
Loan arranged by
The Museum of Russian Art.

The artist was born in 1902 in Pishpek (Frunze), Kirghizia. He studied at VKhUTEMAS from 1921, and at the studio of Robert Falk from 1924 to 1928.

A Daughter of Soviet Kirghizia, one of many paintings by Semon Chuikov on the theme of childhood, is an allegory of the happiness that its creator believed lay in store for all Kirghiz children. The second version of one of the most famous works of art from the Soviet period, *A Daughter of Soviet Kirghizia* is part of Chuikov's series entitled *Kirghizian Collective Farm Suite*, which was created over the course of the preceding two decades and first exhibited in Chuikov's one-man show of 1948. The entire sequence is based on the contrast between the poverty and hopelessness in pre-revolutionary Kirghiz and the advantages of life in the new society. For the artist, the most important benefit of living under Socialism was children's access to free education. This topic was of personal significance to Chuikov given his own miserable childhood, which required him to survive on his wits alone from the age of twelve. *A Daughter of Soviet Kirghizia* takes on a monumental quality through one of Chuikov's typical practices, the depiction of a large-scale foreground figure against a distant landscape.

—⁓—

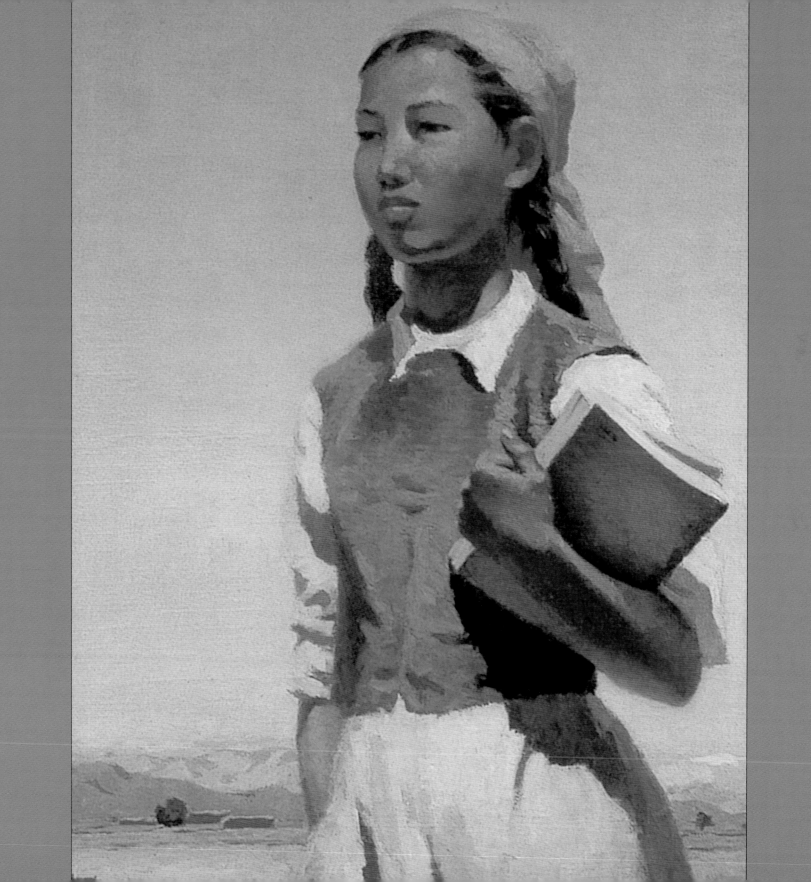

Mai Volfovich DANTSIG

1930 –

Plate 6

Car Crash

1970s
Oil on canvas
104 x 86½ inches

From a Private
American Collection.
Loan arranged by
The Museum of Russian Art.

From 1952 to 1958, Dantsig studied at the Surikov Art Institute in Moscow under M. Kurilko and V. Tsyplakov.

Social engagement is one of the characteristics of the 1960s generation to which Dantsig belongs. The artist has recalled that the outburst of intense emotion depicted in _Car Crash_ is not intended to represent a particular event but to serve as a premonition of world developments, especially in the areas of politics and human relations. In this canvas, Dantsig sought to warn mankind about the possible dangers facing it.

Dantsig often uses large formats when painting. His expressive manner transforms his pictorial themes from routine to important, appearing monumental. His works often become symbols or metaphors, which is characteristic of the Severe Style.

—m—

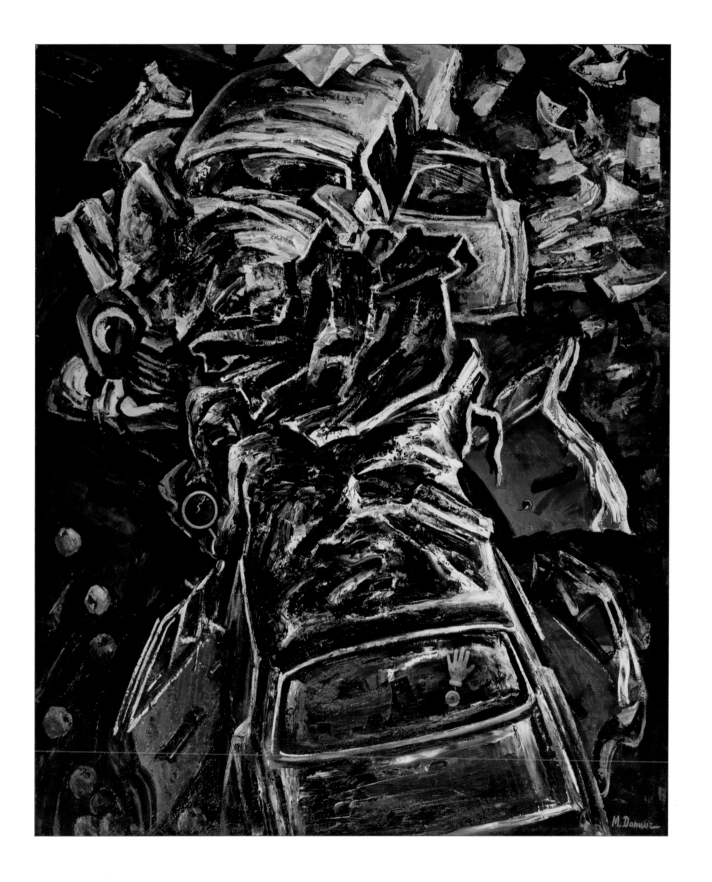

Aleksandr Aleksandrovich DEINEKA

1899 – 1969

Plate 7

Study for a Mural

1930s
Oil on canvas
52⅝ x 77⅝ inches

From a Private
American Collection.
Loan arranged by
The Museum of Russian Art.

Born in Kursk, Deineka studied at Kharkov Art College and at VKhUTEMAS. A founding member of OST and Oktyabr, his work was exhibited in numerous prestigious exhibitions. A versatile talent, he was a graphic artist, sculptor, and a monumental artist who designed mosaics for the Moscow metro.

Aleksandr Deineka was one of the outstanding figures in Soviet art. Among his preferred subjects were industrial and war paintings as well as sports events and collective images of the new Soviet people. This painting, picturing a procession of joyful and determined citizens walking down the street, functions as an allegory of the victory of Communism—the laborious road travelled by ordinary Soviet people leading them to the promised radiant future. This work also features a statue of a discus-thrower: a symbol of the New Man, perfect in every respect.

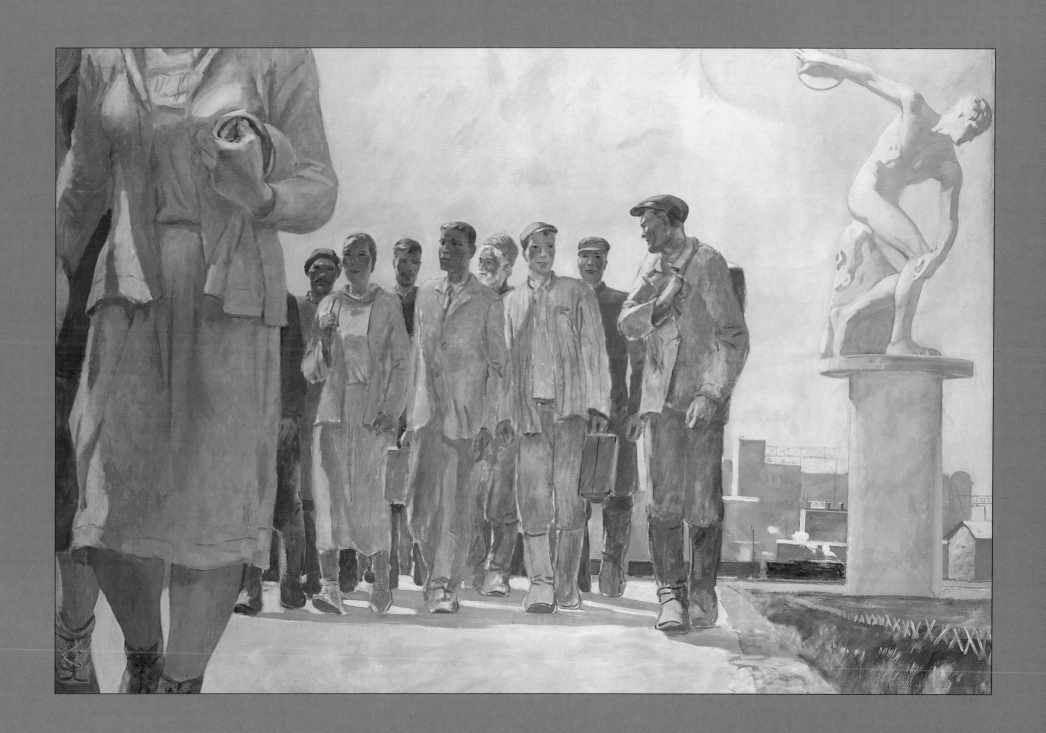

Aleksei Mikhailovich GRITSAI

1914 – 1998

Plate 8

Autumn in the Forest

1990 – 92

Oil on canvas

32¾ x 27½ inches

Gritsai studied in Leningrad at the studio of S. M. Zaidenberg from 1924 to 1931, and at the Institute of Painting, Sculpture and Architecture from 1932 to 1939 under P. S. Naumov, V. N. Yakovlev and I. I. Brodsky.

Gritsai was a master landscape painter who saw nature as the model of earthly perfection providing inspiration to mankind. He believed that man, as one of nature's elements, finds consolation and joy in harmony with it. During the 1990s, the death of loved ones, in combination with Gritsai's own infirmity, restricted the artist's ability to move and work directly from nature, so he often painted from memory. This practice imbued Gritsai's last paintings with a poignant, lyrical mood of reminiscence.

—m—

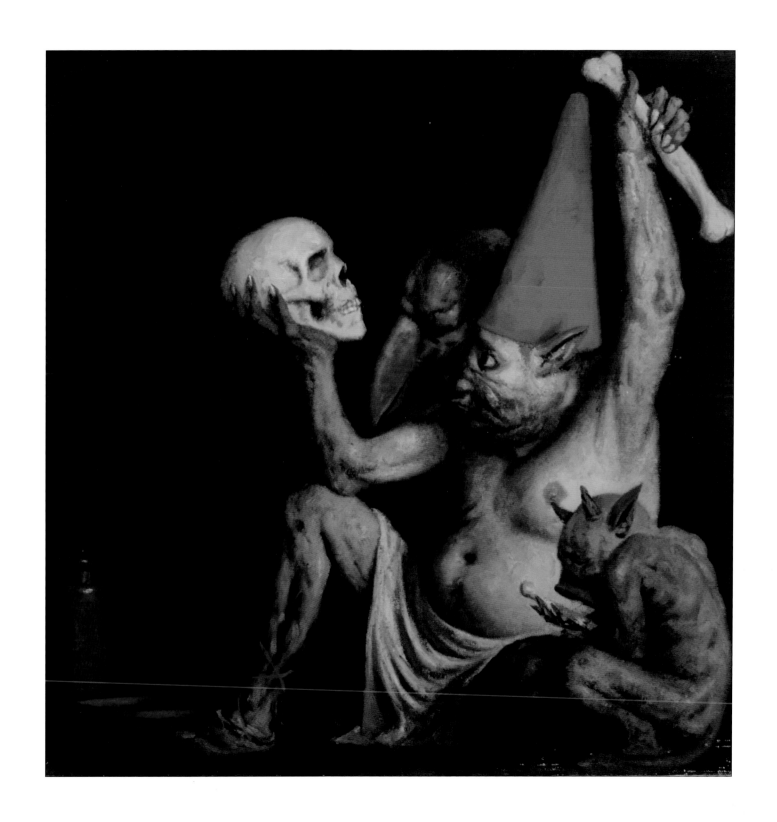

Zinaida Mikhailovna KOVALEVSKAIA

1902 – 1979

Plate 11

Tomato Picking

1949
Oil on canvas
59 x 71 inches

From a Private
American Collection.
Loan arranged by
The Museum of Russian Art.

Kovalevskaia was a student of Nikolai Fechin. She spent almost her entire life in the Soviet Republic of Uzbekistan and founded an art school in Samarkand with her colleague, Pavel Benkov.

A remarkable artist, Kovalevskaia painted this genre scene of Central Asians picking tomatoes. The painting addresses the theme of abundance in postwar life and conveys an impression of joyful labor. The latter is heightened by the exotic beauty of the traditional peasant costumes depicted.

—m—

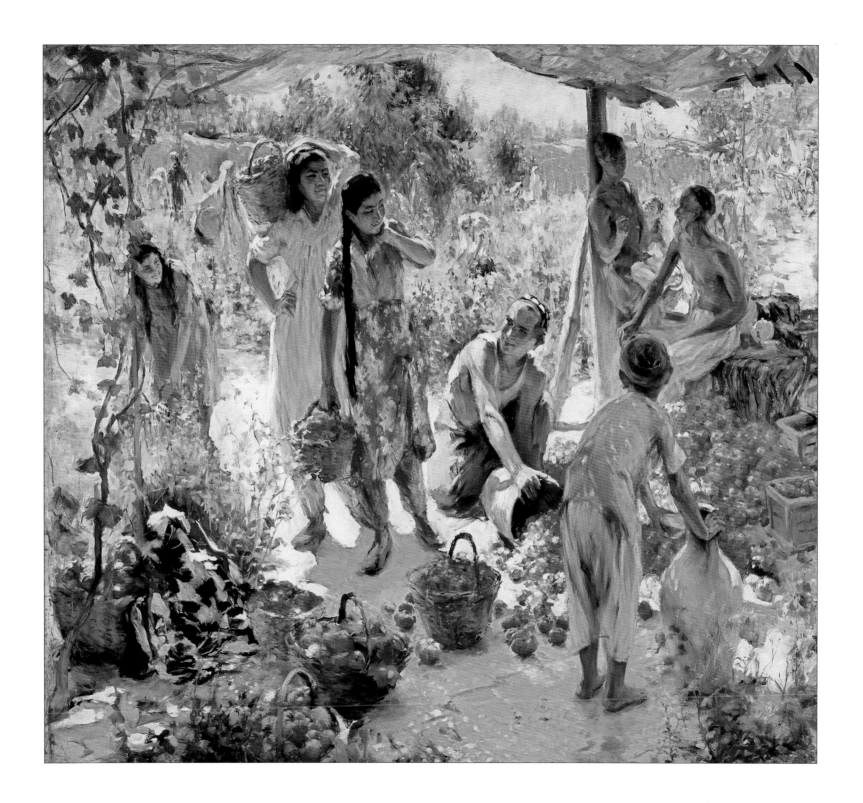

Raisa Vladimirovna KUDREVICH 1919 –
Adolf Samuilovich GUGEL 1915 –

Plate 12

The Big Surprise

1951

Oil on canvas

47 x 52 inches

Both artists studied in Vitebsk. They later married, and together created a number of paintings. In terms of subject matter, _The Big Surprise_ is a typical Soviet-era painting. No real social criticism was tolerated. Only everyday scenes from life, particularly the lives of children, could be represented in an ironic manner for didactic purposes, while ideological principles could never be doubted.

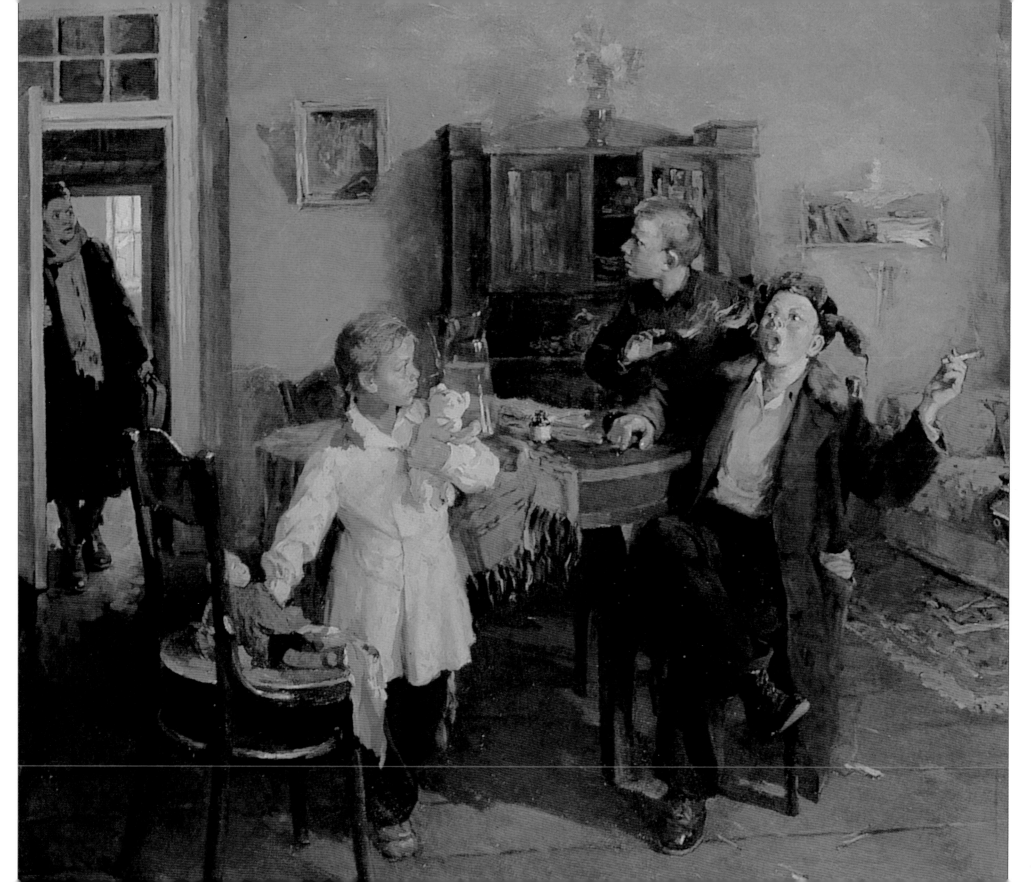

Viktor Fedorovich LETIANIN

1921 –

Plate 13

**_The Deputy, Friend
of the People_**

1965
Oil on canvas
31¼ x 35¼ inches

After the war, Letianin graduated from the Repin Art Institute in Leningrad. There, he studied under R. R. Frents, who specialized in battle scenes. He now lives in Nizhny Novgorod.

Letianin's main subjects are World War II (in which he fought), portraits of contemporaries, and the quiet beauty of the Russian countryside. In the 1960s and 1970s, Soviet society was still preoccupied with the cult of Stalin and its official renunciation. This informed the present painting, a sardonic portrayal of a deputy who neglected his duty and concentrated on his career rather than on representing the interests of his constituents. This painting is almost a documentary scene from a Communist Party congress: a monument to Stalin stands in the background, while the close associates of the leader are seated in the presidium. But the grotesque image of the deputy in the foreground nearly transforms the ceremonial event into burlesque.

—◊—

Grigorii MOTOVILOV

1894 – 1963

Plate 14

A Steelworker

1930

Bronze

33 inches high

Born in Moscow into the family of a doctor, the artist attended medical school from 1915 to 1917 and later worked in a field hospital during World War I. In 1921, he graduated from the VKhUTEMAS, where he studied under Viktor Konenkov.

Motovilov launched his independent art career in 1923. In the 1930s, the sculptor actively searched for new forms of expression in order to depict contemporary Soviet reality.

Gennadii Sergeevich MYZNIKOV

1933 –

Plate 15

Number Four

1990
Oil on board
31⅛ x 26⅜ inches

Born near Moscow, Myznikov attended Mukhina Higher College of Art and Industry in Leningrad from 1950 to 1956. The painter recalled that in the 1960s, at the time of the thaw, Soviet artists had greater opportunities to appreciate world art than they had during the Stalinist era. "For a time I was fascinated by Modigliani, but I was mostly influenced by the Renaissance. I was always interested in the nude as subject matter. The theme itself often dictates the treatment of the image. For me, the nude was never a portrait of a particular person. It was more like admiring beauty." (*Notes from the author's conversation with the artist.*)

—〜—

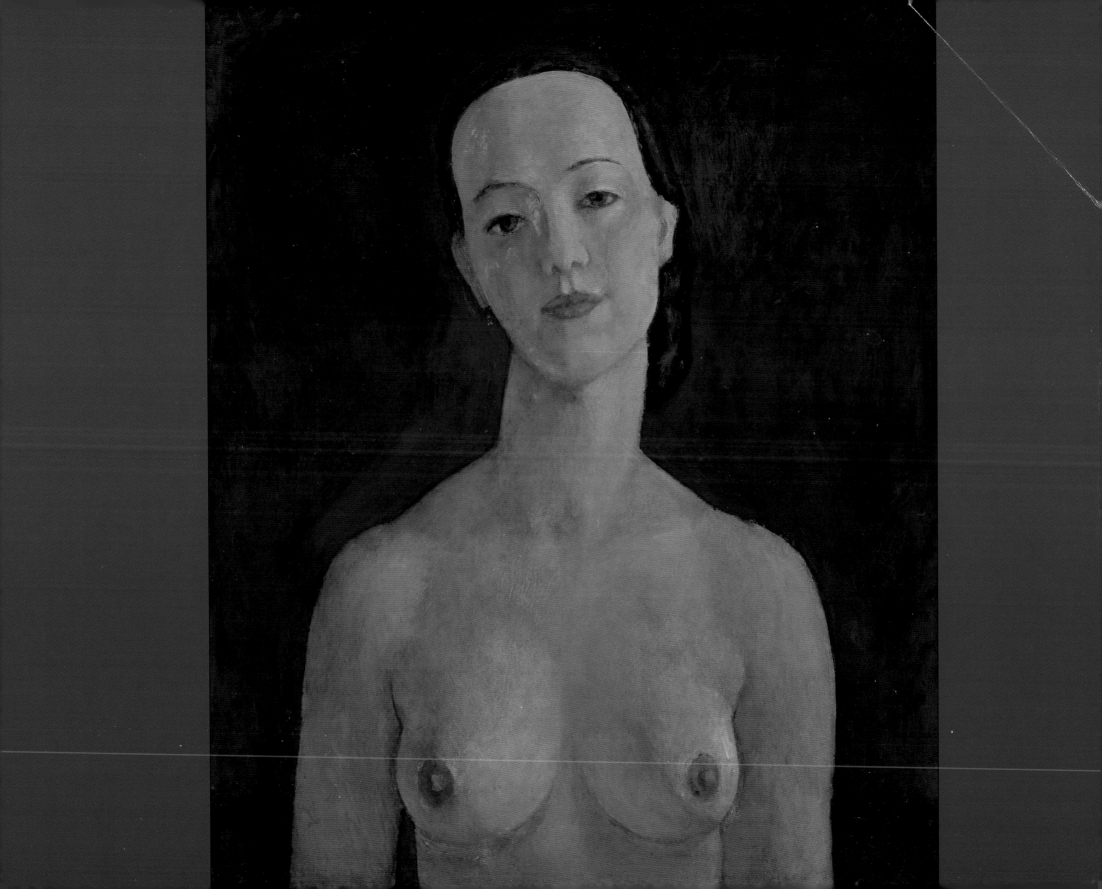

Vasilii Kirillovich NECHITAILO

1915 – 1980

Plate 16

Team Leader

1956

Oil on canvas

70½ x 31½ inches

Nechitailo studied at the Moscow State Art Institute from 1937 to 1942 under S. V. Gerasimov, N. Kh. Maksimov and I. E. Grabar.

The Impressionist traditions of the Moscow school of painting are vividly apparent in the work of Nechitailo. In _Team Leader_, the broad, free brushwork and dazzling whiteness produced in part by the intensity of the sun create a mood of beauty and harmony. This painting of a female laborer was made in the Kuban region, an area the artist liked to visit. Maria Savchenkova, the painter's wife, remembered: "The heat was terrible, it was midsummer. The women, for whom the harvest was a special occasion, put on snow-white blouses and kerchiefs and smartened themselves up. They were in very high spirits."

—⁓—

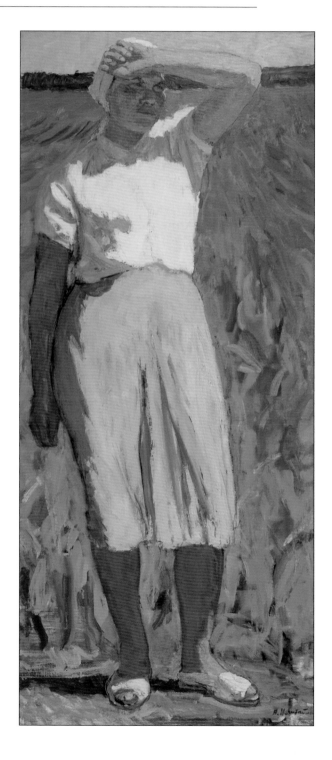

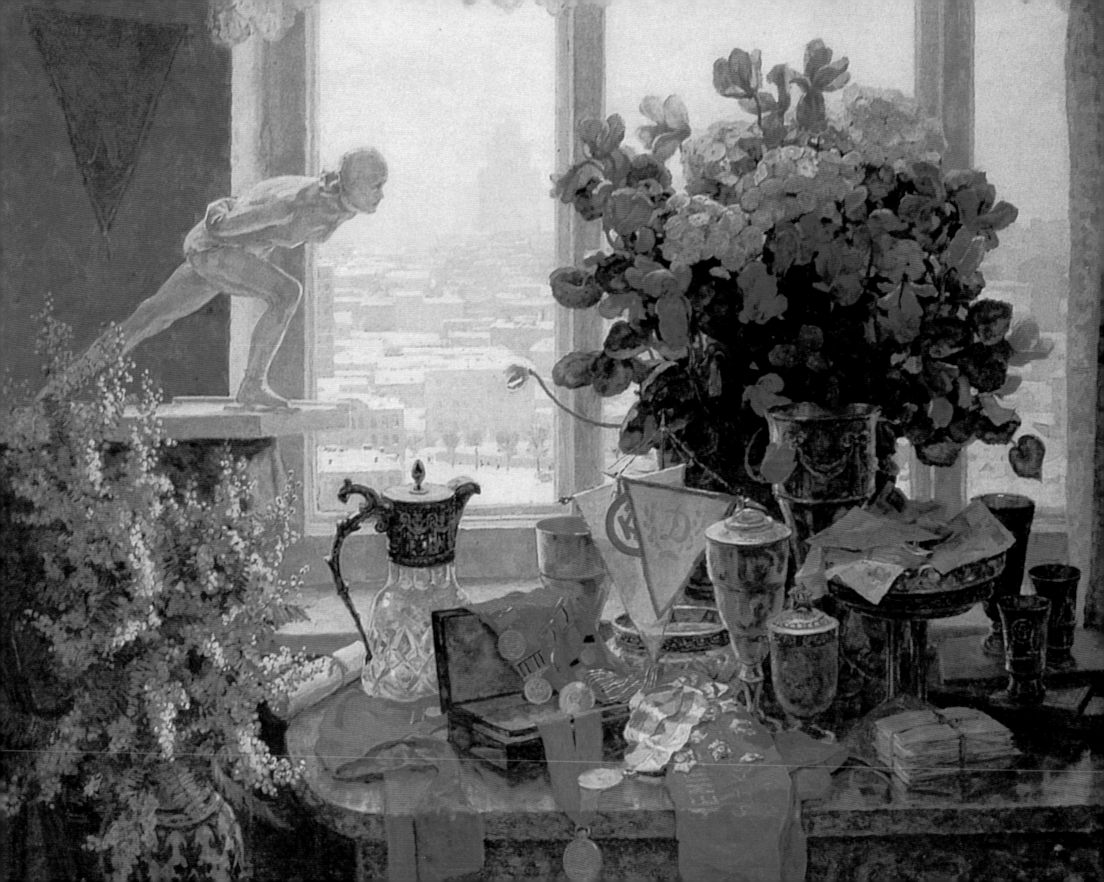

Pavel Fedorovich NIKONOV

1930 –

Plate 19

Meat

1960 – 61
Oil on canvas
48 x 75 inches

Born in Moscow, Pavel Nikonov studied at the Moscow Surikov Art Institute from 1949 to 1956 under P. P. Sokolov-Skalia.

Meat came into being, in Nikonov's own description, as a manifestation of absolute creative freedom, unhindered by any censorship. The artist has characterized this depiction of an animal carcass and a grotesquely rendered butcher as an embodiment of philistinism and the ugliness of life, particularly that surrounding the cult of Stalin. This bold statement was painted for private consumption, with the understanding that no artistic council would ever allow it to be exhibited. Indeed, *Meat* was publicly shown only once, in the Group of 9 exhibition held in Leningrad in 1962. The expressive manner in which the painting was rendered suggests the modernist aesthetics of such avant-garde artists as Chaim Soutine, Marc Chagall and Aleksandr Drevin. However, Nikonov has stated that he was unaware of these figures due to the Soviet Union's nearly complete isolation, and that his style arose purely as the logical result of his own artistic quest.

—⁓—

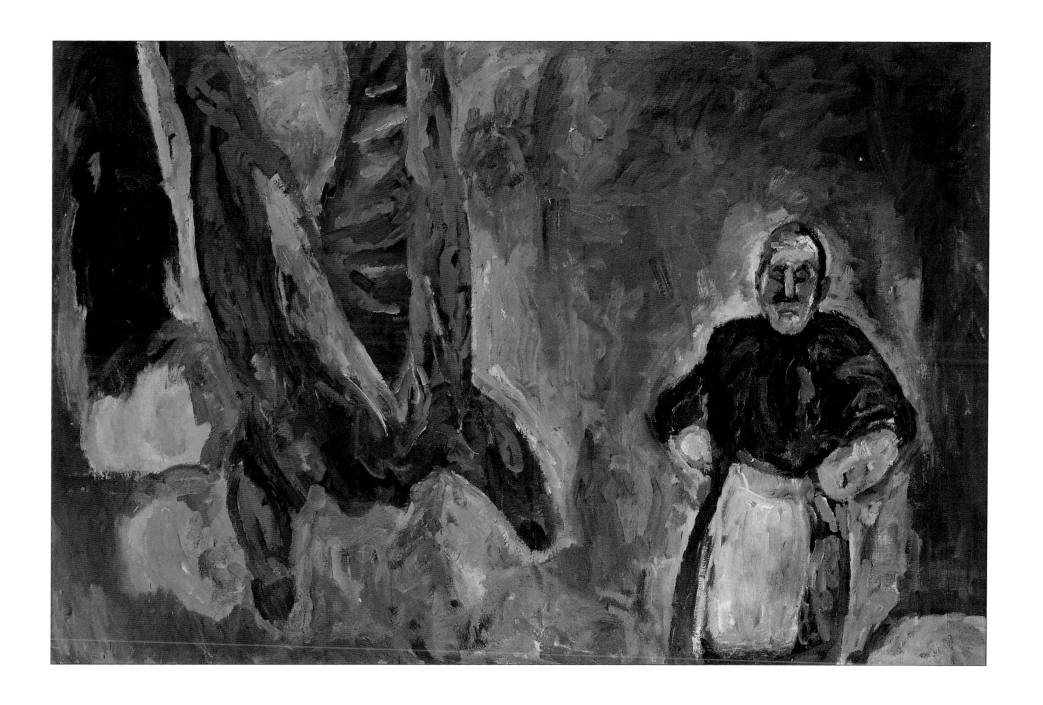

Piotr Pavlovich OSSOVSKY

1925 –

Russian Mothers

1988 – 94

Polyptych

Plate 20

**Expectation
(Heavenly Rays)**

Oil on canvas

67¼ x 67¼ inches

This painting, the first canvas of *Russian Mothers*, portrays pregnancy as a miracle of life.

Born in Ukraine, the artist studied at the Moscow State Surikov Institute from 1944 to 1950 under S. V. Gerasimov. He was one of the originators of the Severe Style.

Russian Mothers is a series of four works inspired by Russian women who had lost their husbands to World War II or, in time of peace, to alcohol-related deaths—the latter of which was especially common in rural Russia. These women who, despite their considerable losses, managed to raise their children and give them the best life possible, strongly influenced the outlook of the post-war generation. The series reflects Ossovsky's belief in the indissoluble unity of nature and man's existence, and in the cyclical, enduring character of life. Ossovsky gave two names to each work in the group, one describing a state of nature, the other an aspect of human life. All the paintings in *Russian Mothers* were created on the Talabsky islands near Pskov, where the artist lived and worked for a long period.

—⁓—

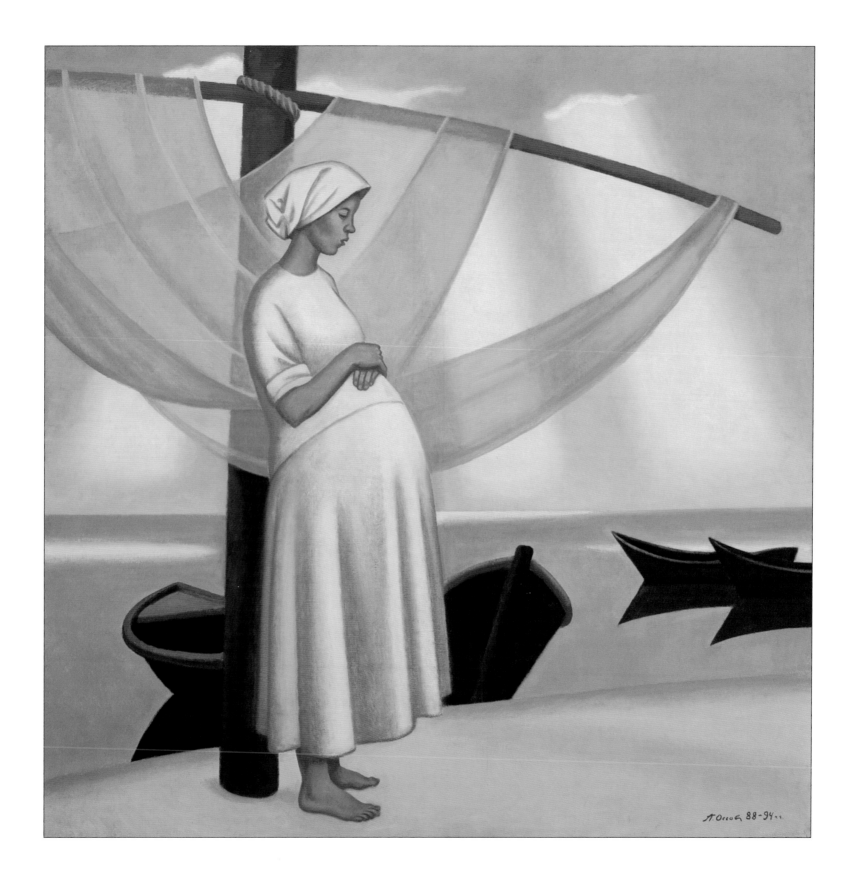

Piotr Pavlovich OSSOVSKY

1925 –

Plate 21

Sad Sun

(Grief)

Oil on canvas

67¼ x 46 inches

According to the painter, this work, the second in the series, was occasioned by the funeral of a young fisherman who had died of alcohol-related causes. Ossovsky notes that the body language of the women and child standing over the grave were taken from life, while the landscape was his own invention.

—◊◊—

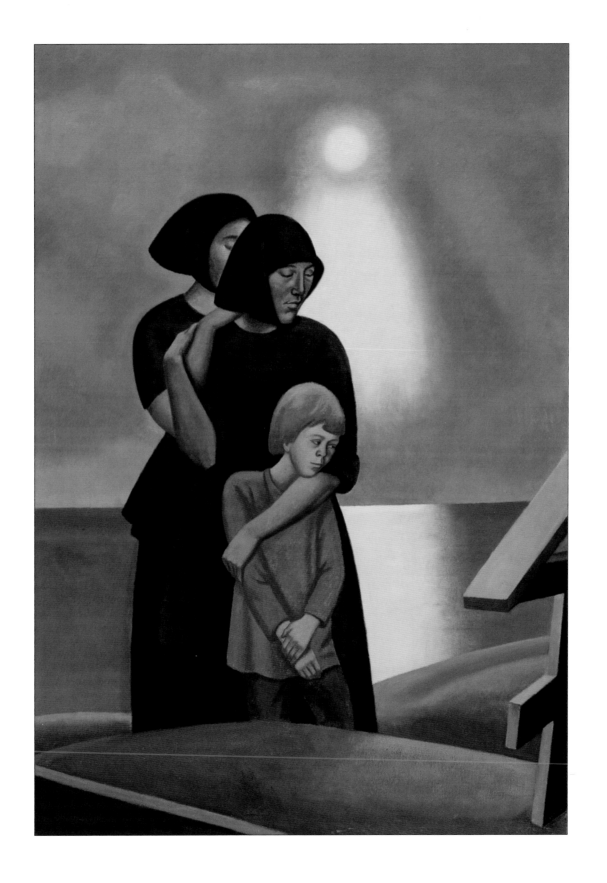

Piotr Pavlovich OSSOVSKY

1925 –

Plate 22

Refugees
(Disaster)

Oil on canvas
67¼ x 46 inches

Historical events and a fisherman's burial prompted this painting as well, the third in the *Russian Mothers* series. The village where the scene takes place was called Aleksandrovsky Posad, named for Tsar Aleksandr I. In 1810 the village burned down, and the sovereign granted a generous sum for its reconstruction. Another conflagration occurred during World War II, when the Nazis drove all the villagers away in boats and set fire to their houses. The peasants managed to salvage only their dearest possession: an icon. A later funeral with the revered icon, which gave the villagers hope and the ability to withstand all hardship, is here treated as a symbol of the continuity of life.

—⁓—

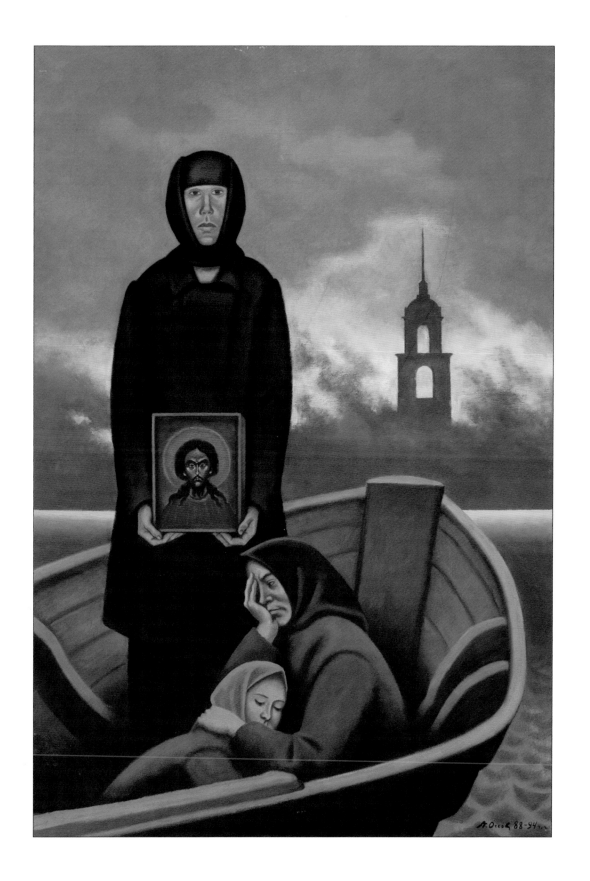

Piotr Pavlovich OSSOVSKY

1925 –

Plate 23

Clear Day

(Motherhood)

Oil on canvas

67¼ x 67¼ inches

This optimistic work concludes Ossovsky's *Russian Mothers* series. In his memoirs, the artist notes that brightness is a symbol of faith and the moral power of mankind. He also explains his lifelong affinity for the fresco technique, which influenced his monochromatic palette:

> I had to overcome the technical difficulties of oil painting to make my works look like frescoes, as if they were transferred from the walls of a temple, its murals picturing human life....To me, my paintings express the difficult life of Russian women and mirror the eternal problems of all mankind. These paintings are religious rather than social. Birth, motherhood, suffering, grief and death are perpetual subjects which pervade the art of masters from many lands, and which they drew from the Bible, the supreme moral law of mankind. (P. P. Ossovsky, Na drevnei zemle Pskova, p. 123).

—⁂—

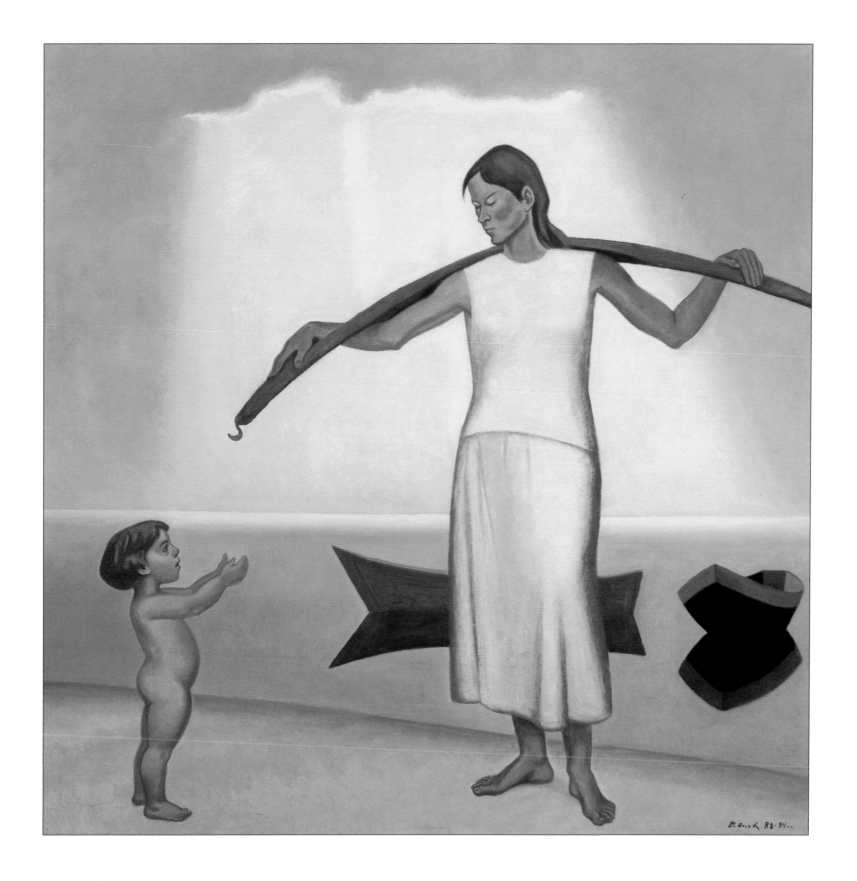

Viktor Efimovich POPKOV

1932 – 1974

Plate 24

Reflection in the Window

1963
Oil on board
28¾ x 20⅛ inches

From 1952 to 1958, Popkov studied at the Surikov Art Institute in Moscow.

Geli Korzhev recalled his fellow artist Popkov:

Popkov studied with the graphics faculty under the direction of the artist Evgenii A. Kibrik. His oeuvre always betrays the hand of a graphic artist; even the contrast of local colors points to a mind that thinks in graphic terms. Popkov was an interesting individual. As an artist he had a sharp eye; he came up with new, fresh subjects, and it is evident that he thought them over carefully. In those years, Popkov often depicted his own home, himself and his friends. He belonged to the generation that was brought up by people who had survived the war. He managed to leave his individual stamp on art. He died early, and it was a very absurd death.

—∽—

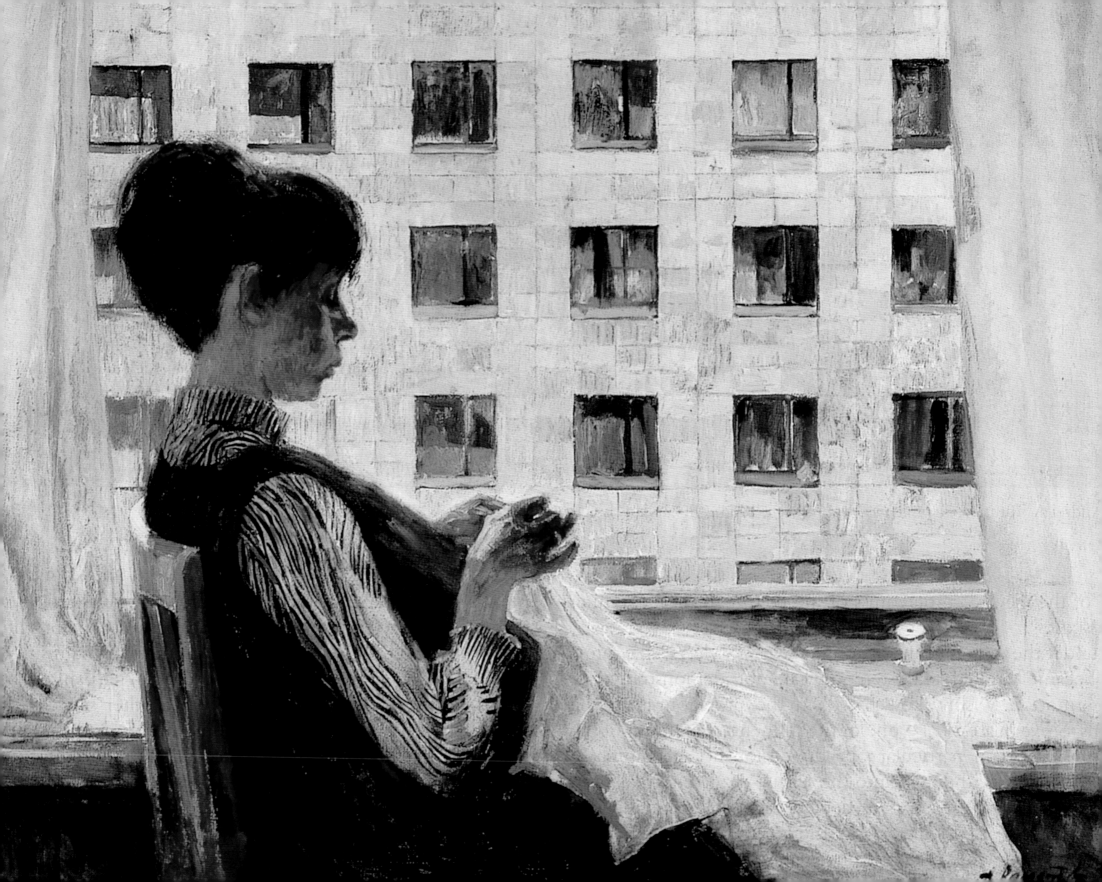

Fedor Vasilievich SHAPAEV

1927 –

Plate 28

**Young Pioneer
at the Door**

1955
Oil on canvas
58½ x 27 inches

Born in the Saratov region, Shapaev entered the Surikov Art Institute in Moscow in 1955, where he studied under V. Gavrilov and K. Maksimov. Perhaps because he spent nearly his entire life in a village not far from Moscow, Shapaev's oeuvre focused on the Soviet village, its peasant inhabitants and landscape. Portraiture of children was one of the officially approved painting genres. The theme of this work, a young girl going to school, is treated in a documentary fashion. The first-grader pictured is not only a student, but a member of the Pioneer organization, which was regarded as the basis of the future socialist motherland. The ideological message could not be missed.

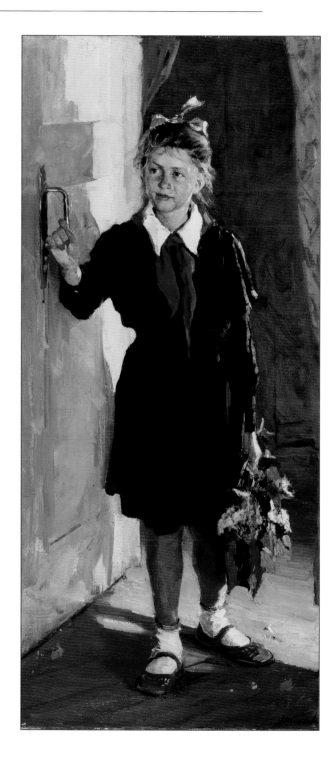

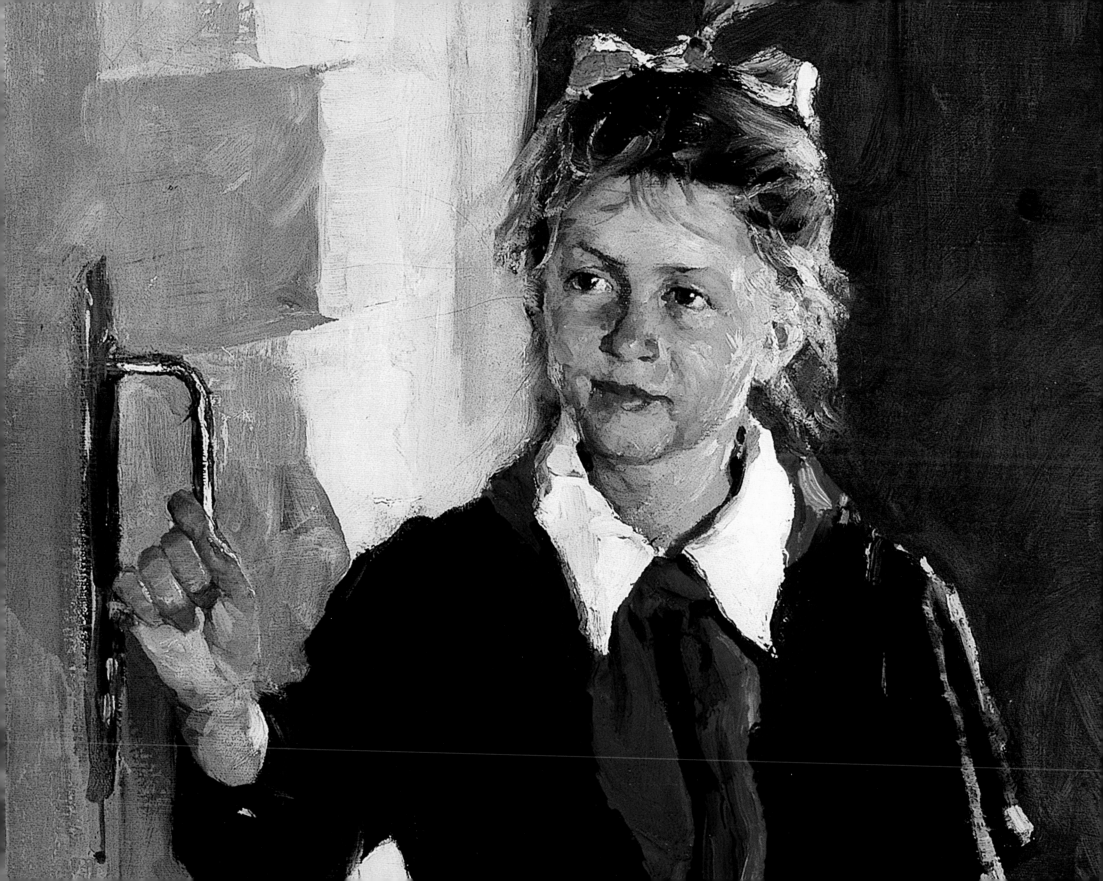

Grigorii Mikhailovich SHEGAL

1889 – 1956

Plate 29

Leader, Teacher, Friend

1937
Oil on canvas
47 x 35 inches

From a Private
American Collection
Loan arranged by
The Museum of Russian Art.

Shegal studied at the Imperial Academy of Arts, St. Petersburg, in 1916 and 1917, and at VKhUTEMAS from 1922 to 1925.

This painting is the artist's variant of one of the most famous works of Socialist Realism, located in the State Tretyakov Gallery, Moscow. It is an example of what was considered the supreme genre in the Soviet artistic hierarchy: the idealized portrayal of the nation's political leaders. This category had its basis in the phenomenon of the "cult of the leader." Immediately after his death in 1924, Lenin was the object of a cult religious in its intensity, while a cult of Stalin emerged several years later rivaling and ultimately overtaking that of Lenin. It is interesting to note that after the denunciation of the Stalin cult, his portraits were destroyed and removed in much the same way that those of repressed revolutionary heroes had been destroyed during his lifetime. The Soviet art expert Igor Golomshtok wonders whether the cult phenomenon was produced by the Soviet leaders or the system. He concludes that Lenin would hardly have been happy about having his own unburied remains in Red Square, but recalls that it was Lenin himself who in 1918 called for the plan of "monumental propaganda" immortalizing revolutionary heroes— a program that, in turn, spawned the cult of personality.

—⚭—

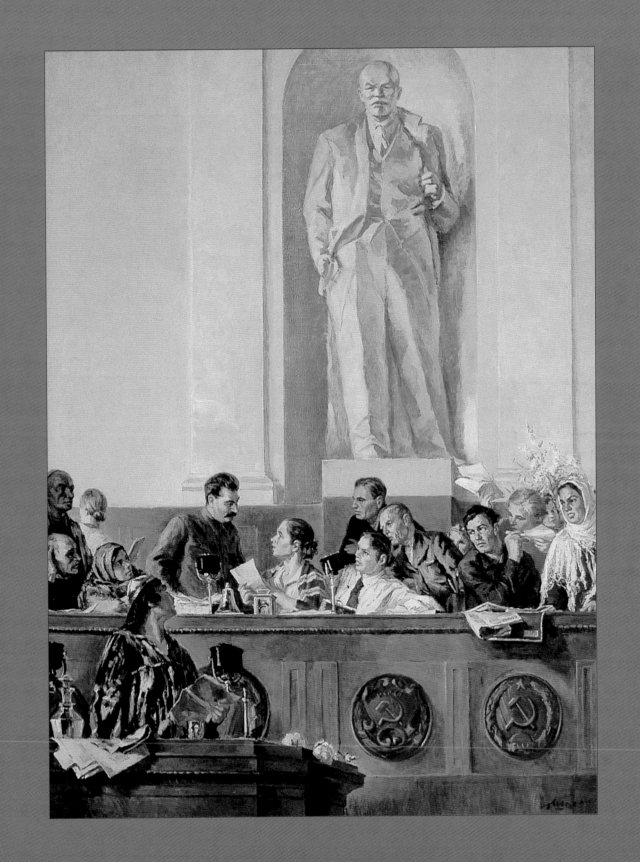

Nikolai Aleksandrovich SHISHLOVSKY

1907 – 1984

Plate 30

Swimmer

1930

Painted wood

15 x 6 x 6 inches

Shishlovsky was a graphic artist, painter and book designer who lived in Moscow. Soviet wood sculpture of the 1930s combined an individualized approach to the model with a generalized portrayal of the new generation. The animated face presented in _Swimmer_ is reminiscent of classical sculpture. It also suggests the influence of proto-Cubism, a Russian avant-garde trend of the early twentieth century that involved the use of wood as a sculptural medium.

Color has been applied to this piece: the painted head represents a swimmer's yellow cap, while a thin, dark strand of hair remains uncovered. Such decorative minimalism, combined with experimentation with various materials, was characteristic of Russian avant-garde sculpture.

—⁓—

Aleksandr SLASHCHEV

Life dates unknown

Plate 31

Football Player

1956

Oil on board

41 x 21 inches

Slashchev lived in Kostroma and does not seem to have been affiliated with any professional artist association.

Football Player is an example of naïve painting of the Soviet period. The work was painted for a specific location—its upper edge is rounded to fit into an arched space. While adhering to the Socialist Realist canon in its representation of a Soviet athlete, the painting also conveys a sense of immediacy and sincere admiration for the beauty of an idealized Soviet "Superman." Here one sees the painted dream of every young boy as well as an example to imitate: a principle of Socialist Realist art, in which the unique was born of the typical and popular.

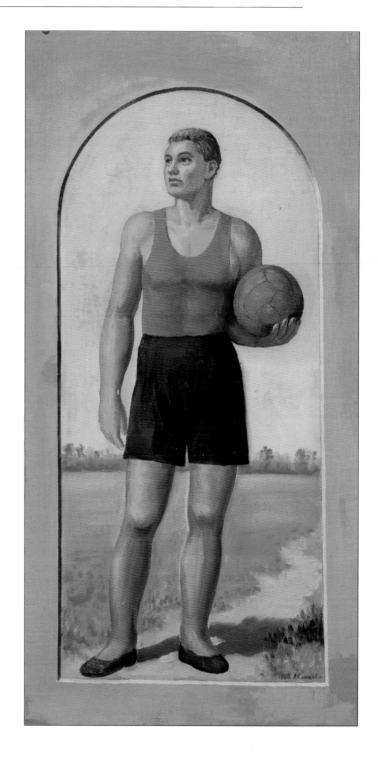

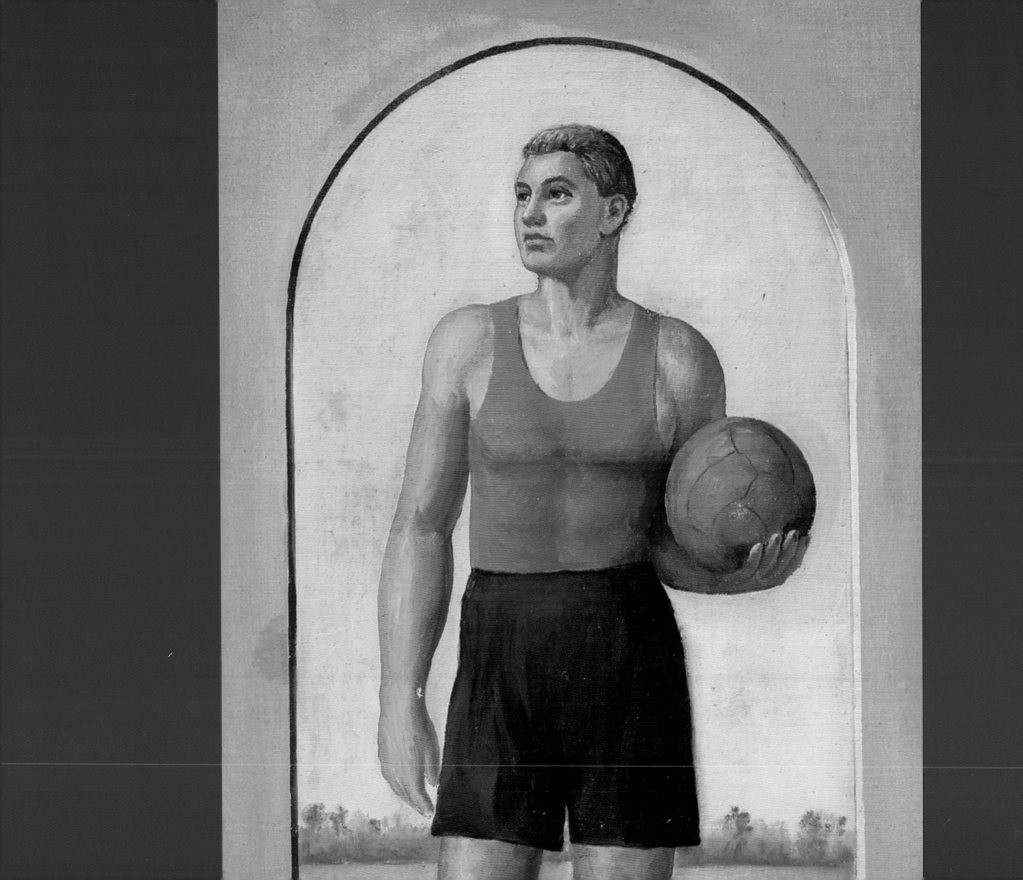

Vladimir Fedorovich STOZHAROV

1926 – 1973

Plate 32

The Gingerbread Arcade

1956
Oil on canvas
41 x 83 inches

From a Private
American Collection
Loan arranged by
The Museum of Russian Art.

Stozharov was a graduate of the Moscow State Surikov Institute, where he studied from 1946 until 1951 under G. K. Savitsky, V. V. Pochitalov and D. K. Schalsky.

Stozharov's friends recall that on his journey through the Russian North, the artist was amazed at the beauty of nature, and it was there that he developed his inimitable use of color. From that point on, his works became more vivid and mature, while landscape emerged as his dominant theme. Stozharov, who traveled extensively, painting from nature, explained: "I would like to convey the enchantment concealed in nature in order to help people experience it. This is so essential in our troubled age. I believe that a man's love for earthly beauty will not permit him to destroy or kill it, but will teach him to protect it."

—m—

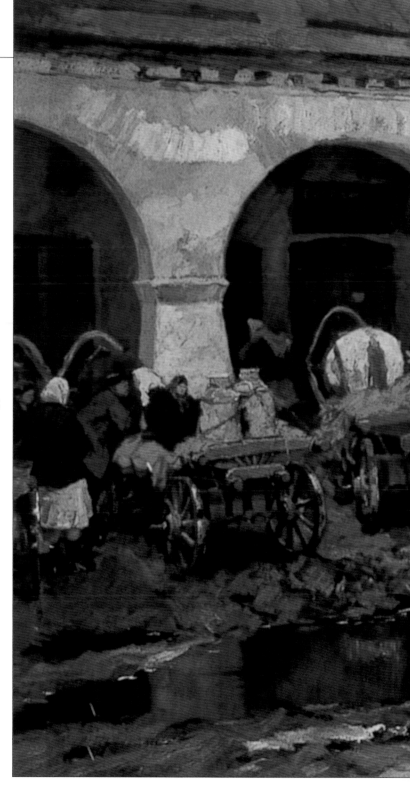

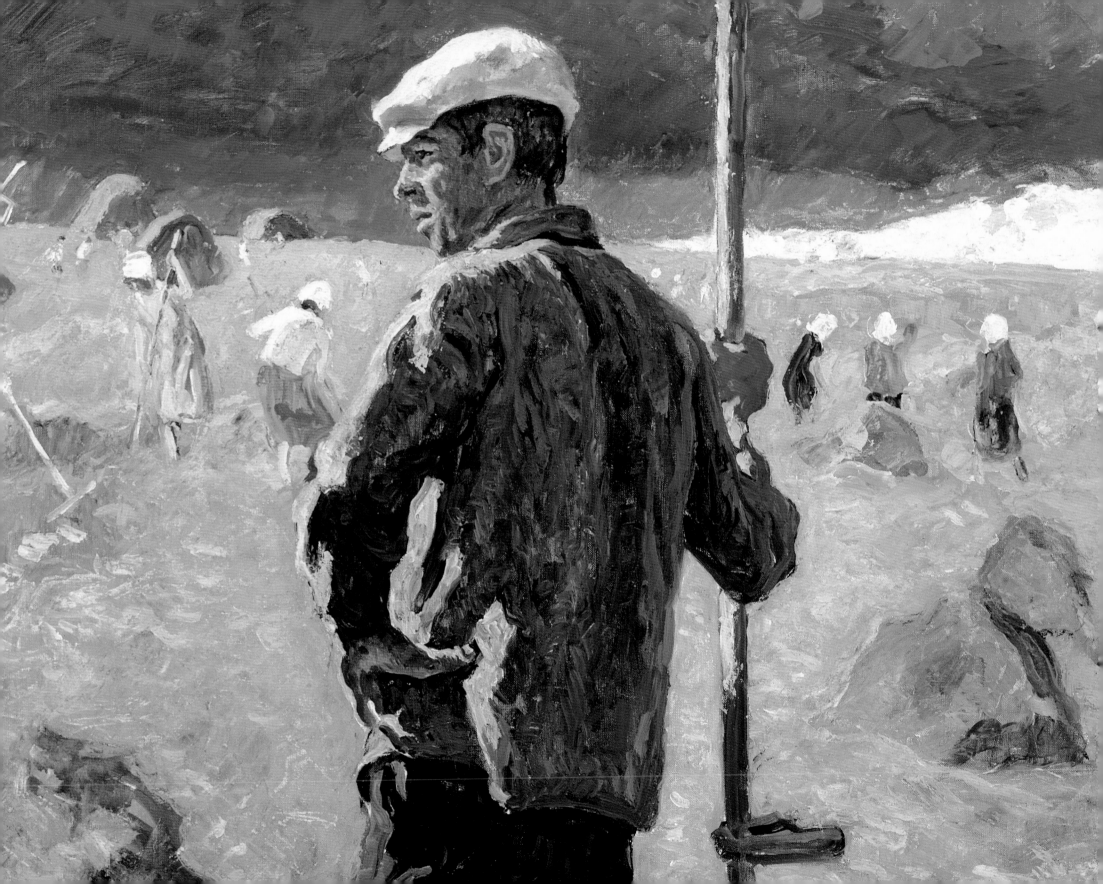

Vladimir Petrovich TOMILOVSKY

1901 –

Plate 35

Construction of the Bratsk Hydroelectric Power Station

1966 – 73

Oil on canvas

41⅛ x 59 inches

Born in one of Russia's Polish provinces, Tomilovsky spent most of his life in Irkutsk, Siberia. During the Civil War (1918–20), he attended the Politprosvet (Political Education) Studio, and in 1930 he graduated from the Irkutsk Art Studio after studying under I. Y. Khazov. A landscape painter, Tomilovsky joined the Union of Artists of the USSR (Artists' Union) in 1937.

In his landscapes, Tomilovsky sought to capture the positive impact of man's interaction with the environment, in particular the transformation of the land through advances in technology. His work often depicted such subjects as the construction of dams, the building of factories and new roads, and lines of electric cables crossing virgin forests. In the artist's words:

Observing for several years the construction of the Bratsk Hydroelectric Power Station, I attempted in a number of works to represent the magnificence of this construction, using such techniques as raising the horizon of the general composition while choosing a more conventional horizon line for those objects and characters within it that seemed to catch my eye and which I intended to stress. I am excited by monumental construction sites, planes rocketing into the sky, cars speeding down the roads, but also by the gentleness of colors and the poetry of life that is present everywhere. So I try to express this in my works to the greatest extent possible.

(From a catalogue of an exhibition devoted to the seventieth anniversary of the artist)

—⁓—

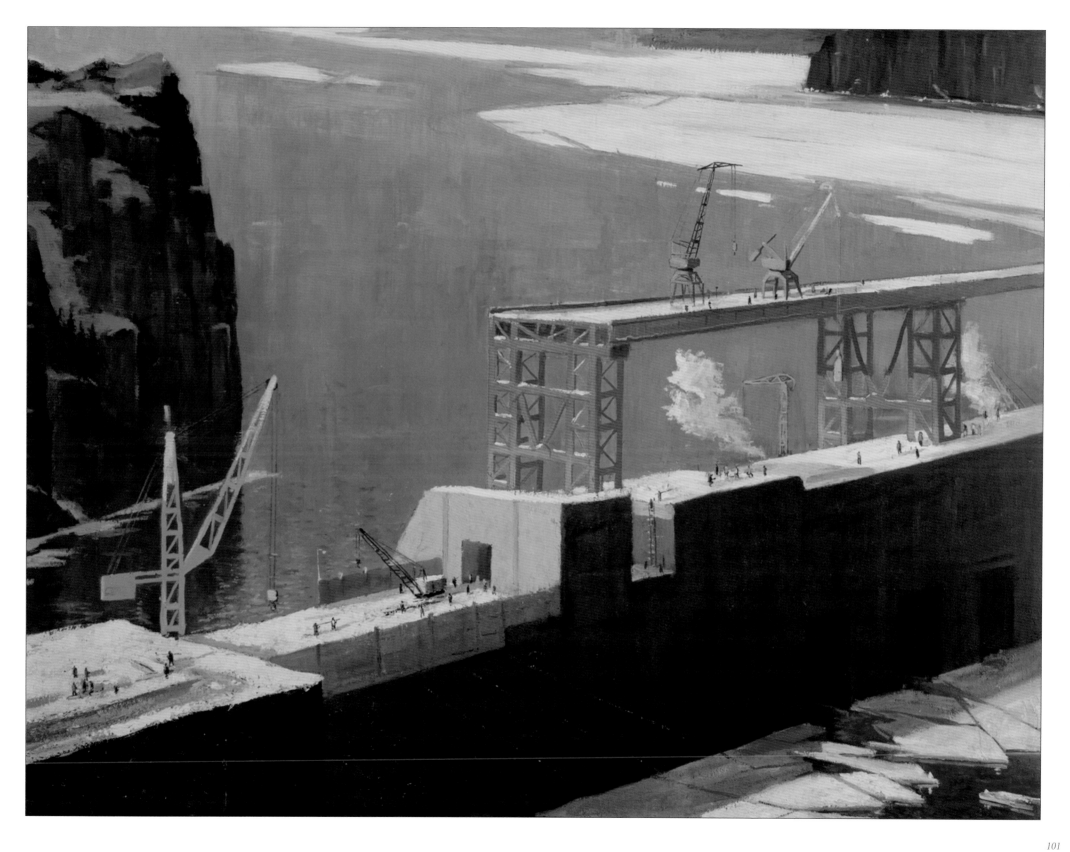

Vladimir Aleksandrovich VASILEV

1895 – 1967

Plate 36

Wartime

1946
Oil on canvas
60¼ x 48½ inches

Born in Moscow, Vasilev studied at VKhUTEMAS from 1918 to 1923, where his teachers were David Shterenberg, Piotr Konchalovsky and A. Osmiorkin. In 1932, Vasilev, who had belonged to OST and then Izobrigada, joined the Moscow Union of Soviet Artists. While his early paintings were influenced by the revolutionary avant-garde, in the 1930s the artist adopted the principles of Socialist Realism. He wrote: "We should infuse our painting with joyful Soviet content. And then… wonderful canvases… will be proper monuments to our epoch" (S. V. Razumovskaia, *V. A. Vasilev*, p. 21).

In the postwar years, Vasilev painted several scenes from World War II. One of these was *Wartime*, to which he also gave the alternate title *Fascism Is War*. Vasilev stated that his goal was to depict a scene he witnessed during the Siege of Leningrad, when the city was under attack by the German forces: a little girl cradled in her mother's arms after being hit by a grenade. The incident moved him greatly, prompting his desire to commemorate the heroism of Soviet women who endured the tragedies of war but remained courageous.

—w—

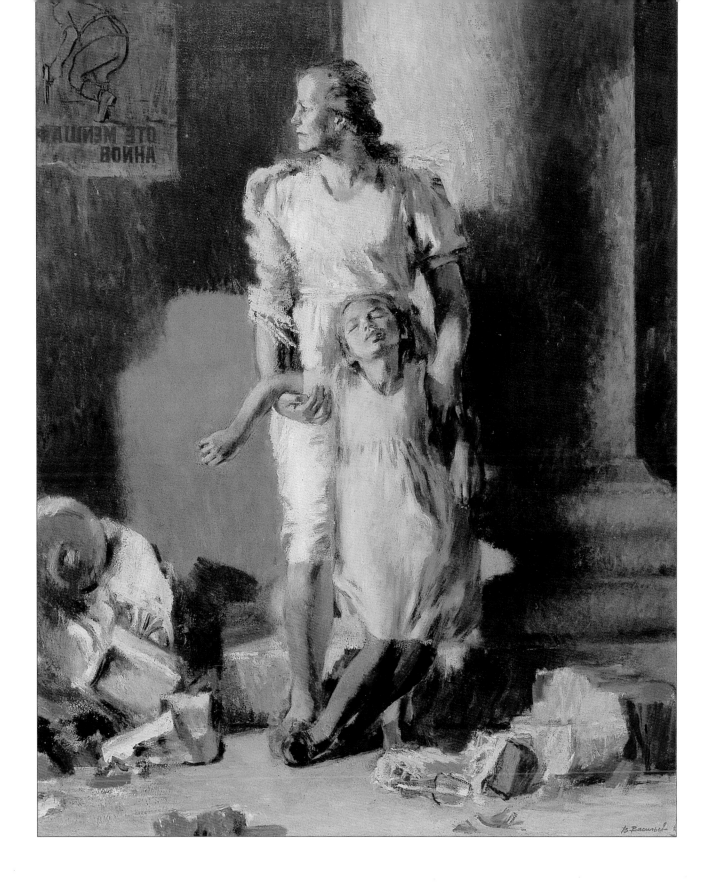

Ekaterina Sergeevna ZERNOVA

1900 –

Plate 37

Tank Driver Kuznetsov

1933
Oil on canvas
47 x 35 inches

From a Private
American Collection
Loan arranged by
The Museum of Russian Art.

Zernova was born in the Crimea. She studied art in Moscow at the private studio of F. I. Rutberg in 1917 and 1918 and later at VKhUTEMAS from 1919 to 1924 under I. I. Mashkov, A. V. Shevchenko and D. P. Shterenberg.

A member of OST until the organization disbanded, Zernova subsequently joined the artistic association Izobrigada and, in 1932, the Artists' Union. Beginning in 1929, she participated in some two hundred and forty exhibitions both at home and abroad.

In *Tank Driver Kuznetsov*, one can see the influence of the OST aesthetic, which merged the avant-garde idiom with figural representation. The artist researched the painting while living with an armored unit deployed near Moscow. In her journal, Zernova noted: "I am drawing soldiers of the Red Army, moving around tanks or standing apart. The commissar looks through my drawings." (E. S. Zernova, "Recollections of a Monumentalist," *Sovetskii khudozhnik* [Moscow, 1985], p. 72.) The work was produced for the 1933 anniversary exhibition *Fifteen Years of the Red Army*.

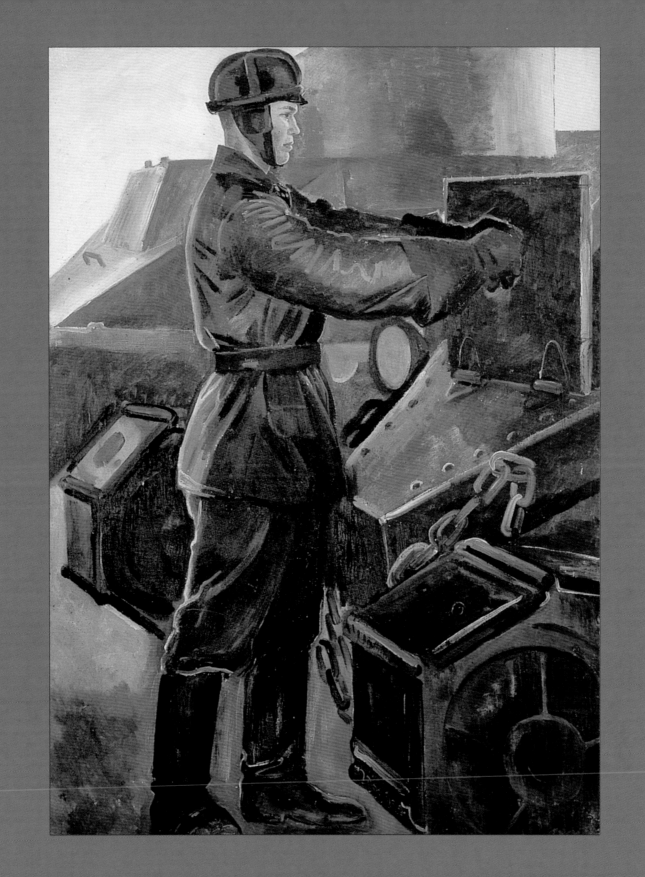

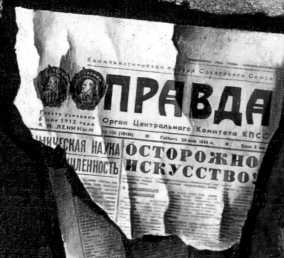

Nonconformist Art

The works in this section are from The Norton and Nancy Dodge Collection of Nonconformist Art from the Soviet Union, on loan from the Jane Voorhees Zimmerli Art Museum, Rutgers, The State University of New Jersey. All were photographed by Jack Abraham, unless otherwise noted.

Narratives in this section were compiled from many different sources by Kim Sels, Graduate Research Assistant for the Dodge Collection, and Dr. Rosenfeld. Editorial assistance was provided by Jane Friedman, Independent Scholar, and Natalia Kariaeva, Graduate Research Assistant. Technical support was provided by Kristina Narizhnaya, Undergraduate Intern.

Aleksandr AREFIEV

1931 – 1987

Untitled

1954
Watercolor, graphite,
and gouache on paper
12⅛ x 14¼ inches
09451

Arefiev was born in Leningrad. He was a leader of the so-called Arefiev Circle of Leningrad underground artists of the mid-1950s who today are considered icons of Russia's counterculture movement. Because they created art outside of the officially sanctioned institutions, the Arefiev Circle artists were unable to take part in official exhibitions or to receive official commissions, and most of them ended up in poverty.

Regarding official Soviet art and culture as morally, socially and emotionally bankrupt in the aftermath of World War II, Arefiev was among the first to reject the idealized vision of Soviet existence espoused by Socialist Realism. Instead, he focused on the margins of Soviet society and the dreary aspects of everyday Soviet life. Arefiev's raw and gritty subject matter was matched by his candid, confrontational realist style.

Arefiev was expelled from Secondary Art School in 1949, and developed a drug addiction that led to a three-year prison term for forging prescriptions. These difficulties, however, provided the themes for Arefiev's work: scenes from the lives of societal outcasts, images of the Soviet labor camps, and views of partially destroyed or deteriorating Leningrad buildings devoid of any poetic beauty in the aftermath of the war. The sense of immediacy and drama in Arefiev's work is often produced by means of the artist's expressive use of figural distortion and handling of paint. In this way, Arefiev's expressionistic and emotionally charged oeuvre was diametrically opposed to the tenets and look of Socialist Realism. In 1977, Arefiev immigrated to Paris. The following year, alone and despondent, he died of liver failure.

—⁂—

Aleksandr AREFIEV

1931 – 1987

Plate 39

Untitled

1955

Watercolor, gouache,

and graphite on paper

7¾ x 9¼ inches

02927

Grisha BRUSKIN

1945 –

Plate 43

Rule of the Pioneers

1984
Oil on canvas
21 x 23¾ inches
12024

The artist was born, educated and worked in Moscow. He now lives in New York.

Bruskin graduated from the Moscow Art Institute in 1968 and had his first solo exhibition at the Central Artists' House in Moscow in 1976. Although accepted into the Artists' Union, Bruskin's nonconformist sculpture and painting garnered negative attention early in his career when the government, suspecting him of Zionism and other anti-Soviet tendencies, closed his exhibitions in Moscow and Lithuania.

Bruskin distanced himself from his everyday surroundings by satirizing Soviet life and retreating to Jewish traditions and literature for inspiration and escape. He became one of the few contemporary Soviet Jewish artists to produce work with explicitly Jewish content while exploring the iconography of Socialist Realism. As a sculptor and painter, Bruskin is best known for his plaster and stainless steel casts reminiscent of Soviet propagandistic statues that coexist with mythological figures of angels and demons, as well as his ironical, narrative treatment of Soviet society's patriotic slogans and figures.

—m—

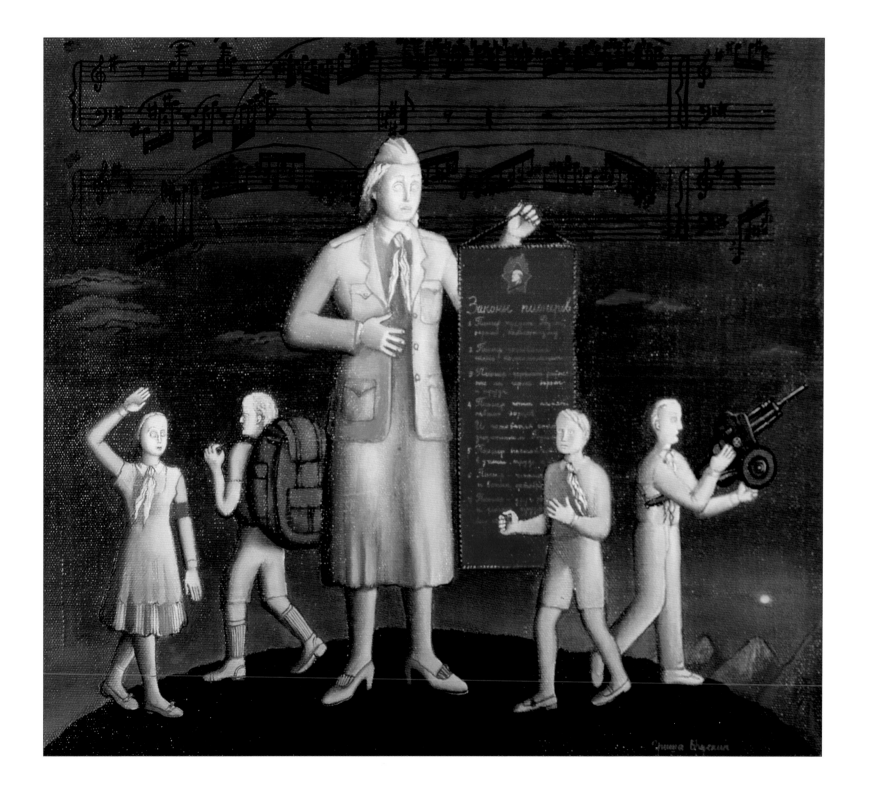

Grisha BRUSKIN

1945 –

From the series
The Birth of the Hero

Plate 44

***Boy with a Gas Mask
and Shovel***

1985 Bronze and painted metal
11¾ x 7¾ inches
17226/2000.0756

Plate 45

***Marshall with the Slogan
"Socialism is Invincible!"***

1985 Bronze and painted metal
15¼ x 7 inches
17227/2000.0757

Plate 46

Soldier with a Frontier Post

1985 Bronze and painted wood
15⅝ x 8¼ inches
17225/2000.0755

The Birth of the Hero

(A Statement by Grisha Bruskin)

In the 20th century, Russians, like ancient Egyptians, lived under the power of ideological myth. A characteristic of Soviet Russia was sculpture-mania. Plaster Pioneers, collective farmers, generals, and athletes reigned everywhere: in squares and parks, on facades of buildings and in the subway, forming a realm of the dead in the world of the living. These sculptures represented ideal images and the notion that the hero of Soviet society was in fact a new form of human being—"homo sovieticus." They also commanded ordinary people "to be like us!"

The *Birth of the Hero* series is reminiscent of Soviet architectural and park sculpture, the sculpture of monumental propaganda. It is a collection of ideological archetypes, museum pieces for art viewers of the 21st century who will look at these sculptures the way we now contemplate artifacts from Ancient Egypt. It includes religious-magical, mystical characters: angels and demons, symbolizing God and Evil—between which the Soviet man's life was passing and between which any individual's life is still passing.

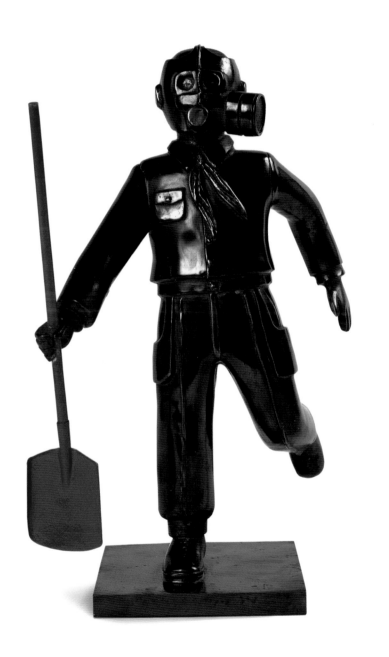
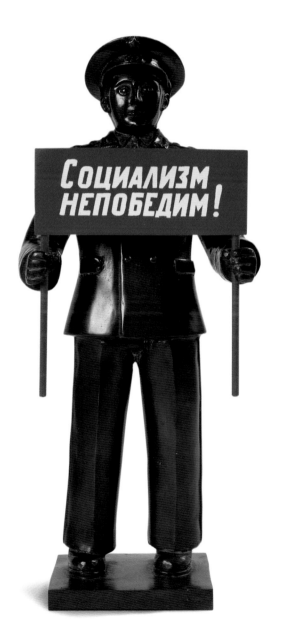
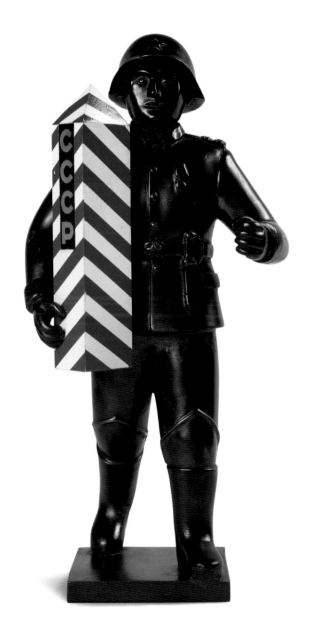

Социализм непобедим!

СССР

Grisha BRUSKIN

1945 –

Plate 47, Plate 48

Male Beast

1985 Bronze

14⅝ x 8¼ inches

17231/2000.0761

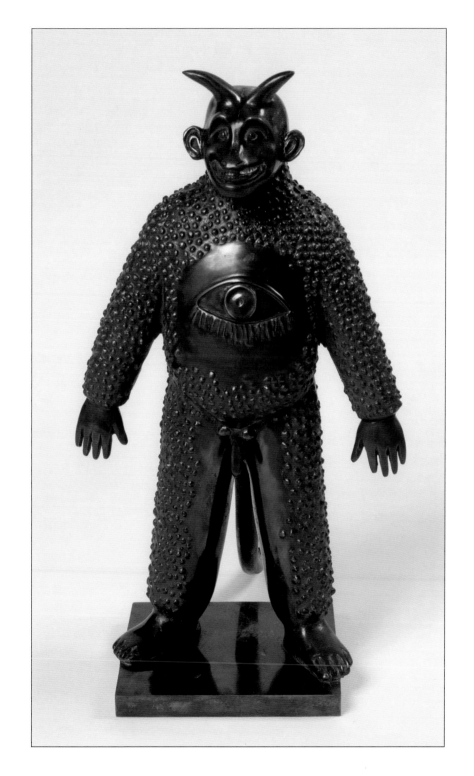
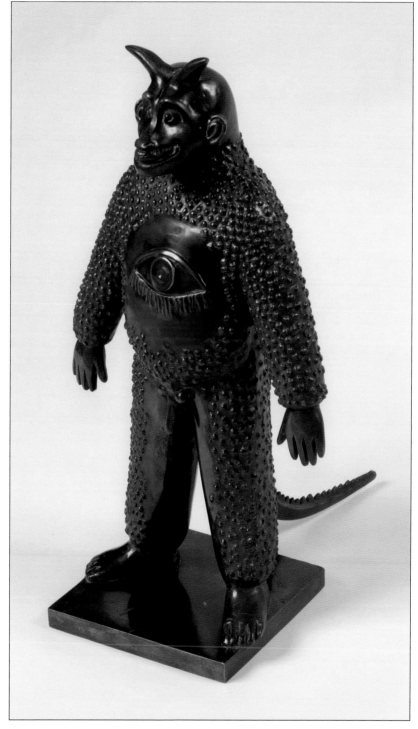

Eric BULATOV

1933 –

Plate 49

The Poet Vsevolod Nekrasov

1981 – 85
Oil on canvas
78⅜ x 78⅜ inches
05123/1999.0671

Bulatov was born in Sverdlovsk, Russia, worked in Moscow and now lives in Paris.

Bulatov was one of the most important members of the nonconformist art movement. After having trained at the Surikov Art Institute in Moscow from 1952 to 1958, Bulatov realized that his academic training was insufficient. He then proceeded to undergo what he refers to as his "retraining," which introduced him to the ideas of the Russian avant-garde and Western contemporary art trends. In the early 1960s, Bulatov began experimenting with conceptual art. He appropriated texts and Socialist Realist images from Soviet propaganda, the juxtaposition of which accentuated the ambiguities of life in the Soviet Union.

In *The Poet Vsevolod Nekrasov*, Bulatov appropriates an image from a photograph depicting the poet smiling broadly with his eyes shut. According to Bulatov, Nekrasov's writing is closely associated with his own work, and preoccupation with things "that are common knowledge, self-evident, obvious" constitutes the common ground between the poet and Bulatov. Unlike the sharp, clear light that illuminates many of Bulatov's works, the poet is here bathed in a hazy illumination that makes the portrait look photographically underexposed.

—⁓—

Eric BULATOV

1933 –

Plate 50

At the TV

1982 – 85

Oil on canvas

45¼ x 62⅜ inches

05133/2000.0867

Alexander KOSOLAPOV

1943 –

Plate 57

Baltika

1973
Oil on wood
35½ x 14⅜ inches
04351

Born in Moscow, Kosolapov worked in Moscow and now lives in New York.

Though officially trained as a monumental sculptor, Kosolapov's nonconformist work often juxtaposes logically incompatible elements. Influenced by Dada and by Russian absurdist poetry of the 1920s, his work insists on the need to free objects from their traditional associations. This results not only in witty and ironic compositions, but also in works that shape the viewer's reaction in terms of symbolic context rather than literal content. As a Sots Art artist, Kosolapov appropriated elements of Soviet kitsch, often found by chance, to satirize Soviet ideological mass production.

—〜—

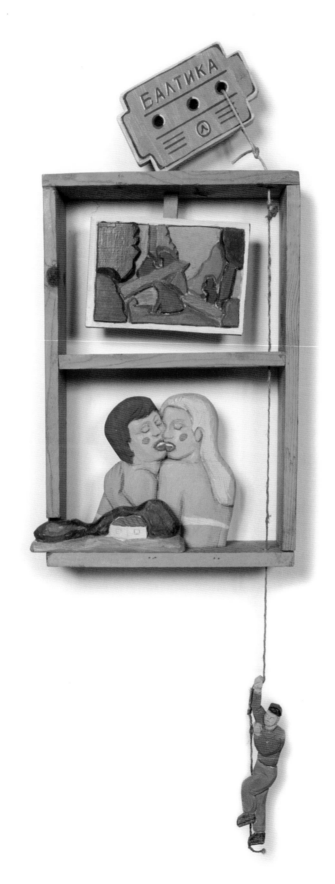

Alexander KOSOLAPOV

1943 –

Plate 58

Molotov Cocktail

1989
Acrylic on canvas
47⅜ x 59¼ inches
17469/2001.0514

After his immigration to New York in 1975, Kosolapov began appropriating various elements from both Pop Art and Sots Art imagery and by infusing elements of parody and irony, exposed their manipulative effects. In his works, Kosolapov often juxtaposed these American consumer images with those derived from official Socialist Realism.

—m—

Leonid LAMM

1928 –

Plate 59

***Assembly Hall,
Butyrka Prison***

1976
Pen and ink,
watercolor on paper
19⅜ x 19⅜ inches
07029/1991.0874

Lamm was born in Moscow, worked in Moscow and now lives in New York.

The work of Leonid Lamm combines historical and personal experience, elements of mass media, and individual expression. In the 1940s, Lamm was a student of Iakov Chernikhov, a leader and practitioner of the 1920s Russian Constructivist movement. During the mid-1960s, Lamm became interested in Jewish mysticism and began to produce abstract painting influenced by Kabbalistic writing. Like many other nonconformist artists, he also supported himself as an illustrator and book designer. Lamm's application in 1973 for a visa to immigrate to Israel resulted in his arrest and imprisonment in Moscow's Butyrka prison. Many of Lamm's works, realistically depicting the routine of incarcerated life, reflect the artist's experience under arrest, from 1973 to 1976, in Butyrka Prison and a labor camp. While Lamm was still in prison, his wife showed his works at the Second Autumn Open-Air Exhibition in Izmailovsky Park, Moscow. In 1982, Lamm immigrated to the United States and settled in New York.

As in *Assembly Hall, Butyrka Prison*, Lamm's works are rarely narrative but rather reflect the fragmentation of his memory of prison life. Often included in the artist's compositions are mathematical equations and measurements, which both measure spaces and refer to the tendency of contemporary societies to control and standardize life inside and outside of prison. As also seen in this work, Lamm incorporates actual slogans of the prison's "educational orientation program," for example, "To Freedom with a Clear Conscience!"

НА СВОБОДУ, с ЧИСТОЙ СОВЕСТЬЮ!

Rostislav LEBEDEV

1946 –

Plate 60

Situation No. 2
(No Exit)

1979
Painted wood
construction
52¼ x 57⅞ inches
01519.01–06

The artist was born in Moscow and continues to work there.

After graduating from the Art Department of the Moscow Pedagogical Institute in 1969, Rostislav Lebedev began to paint in the style of French Fauvist painters like Raoul Dufy and André Derain. His desire to be part of the contemporary art scene, however, prompted his own independent study of Western books and journals. In the 1970s, Lebedev turned to conceptual art. Out of his interest in signs and their continually fluctuating meanings, Lebedev began constructing the assemblages that became typical of his oeuvre.

In *Situation No. 2*, Lebedev explores everyday sign systems by incorporating the commonly displayed phrase "No Exit" into his wood construction. The appropriated phrase appears on each of the inside panels of his red hexagonal enclosure, which, literally speaking, does indeed prevent anything from exiting. It is likely, however, that the construction refers not only to the Soviet prevention of emigration, but also to the general feeling of inertia and entrapment in Russia.

—∾—

Vladimir NAUMETS

1945 –

Plate 63

Untitled

1982

Gouache and ink

on photocopy on paper

16⅜ x 11⅝ inches

10073.04

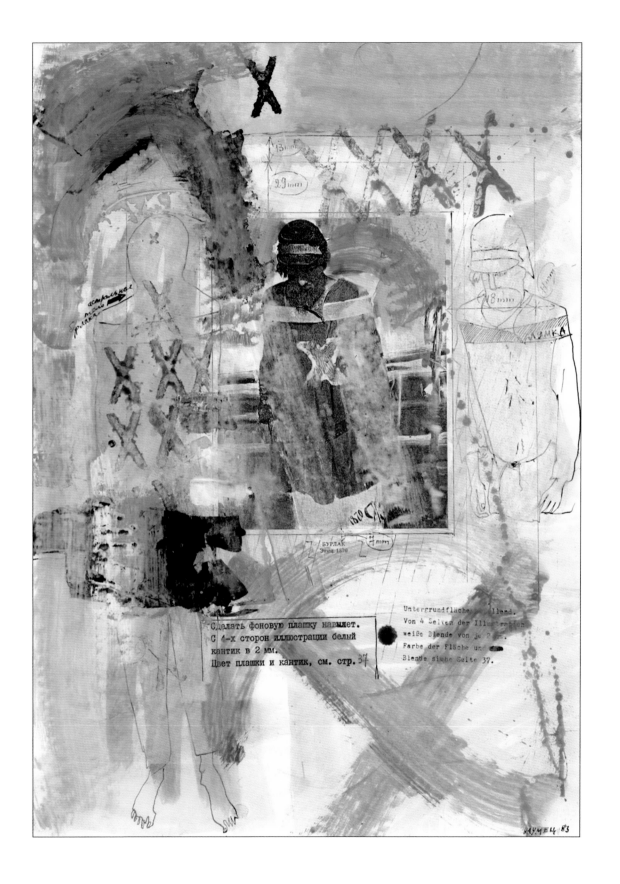

Vladimir NEMUKHIN

1925 –

Plate 64

Composition

1961
Oil on canvas
61⅝ x 42⅛ inches
07849/1992.0548

Nemukhin's mature style evolved out of his early examinations of Surrealist biomorphic imagery and works by Abstract Expressionists, which he saw in 1957 at the Sixth World Festival of Youth and Students in Moscow.

A first-generation Moscow nonconformist, Vladimir Nemukhin studied art during World War II with Pavel Kuznetsov and Petr Sokolov, distinguished teachers of the former Stroganov School, a place where artistic craftsmanship was accorded first priority. Sokolov, a former student of Malevich, introduced him to the prohibited styles and theories of the Russian avant-garde and Western art. Nemukhin later continued his studies at the Surikov Institute and was introduced to like-minded, political-activist artists. He joined the Lianozovo community in the 1960s. Nemukhin not only participated in but also served as negotiator between the artists and authorities during the "Bulldozer Exhibition" in 1974 and continued to act as a mediator with great skill and success through 1987.

A native Muscovite, Nemukhin now divides his time between Moscow and Germany.

—⁓—

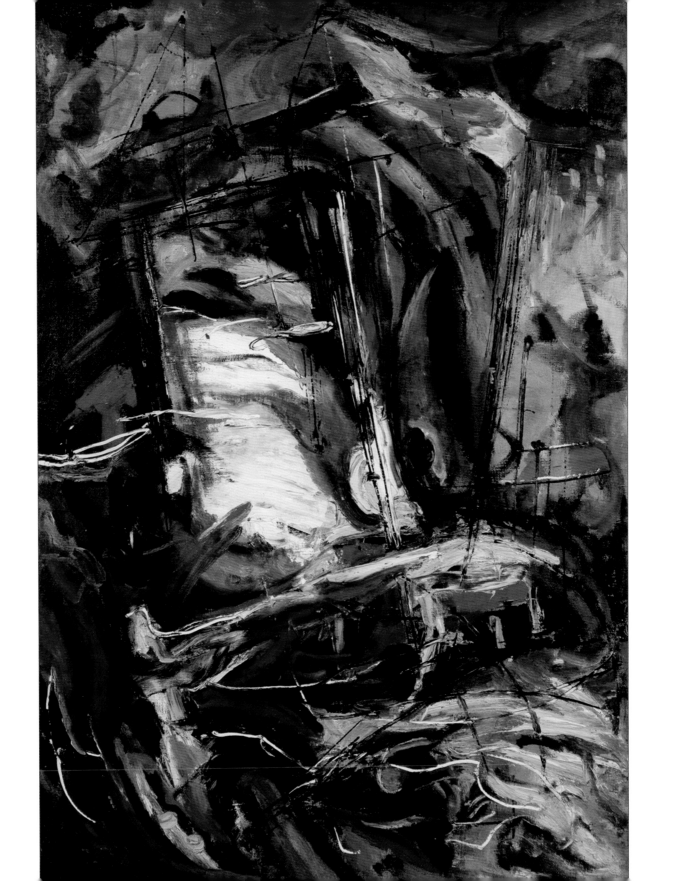

Boris ORLOV

1946 –

Plate 65

The General

circa 1975

Painted wood

46⅜ x 36⅝ inches

14194

The artist was born in Moscow and continues to work there.

Orlov graduated from the Stroganov Art Institute in Moscow in 1966 and worked as a sculptor, focusing primarily on assemblages. His most representative pieces come from the series *Ceremonial Portraits*, done in the late 1970s.

As seen in *The General*, Orlov's "portraits" are not images of real individuals but of social types that replace individuals in a totalitarian society. As a result, most of his "portraits" are faceless busts, lacking any features that could relate the image to a person. They are assemblages of social insignia and recognizable accessories, the elements of which are simplified, flattened, enlarged: social symbols take over, erasing the person that bears them. The busts thus subvert the very notion of portraiture and emerge as iconic incarnations of the totalitarian regime.

—⁓—

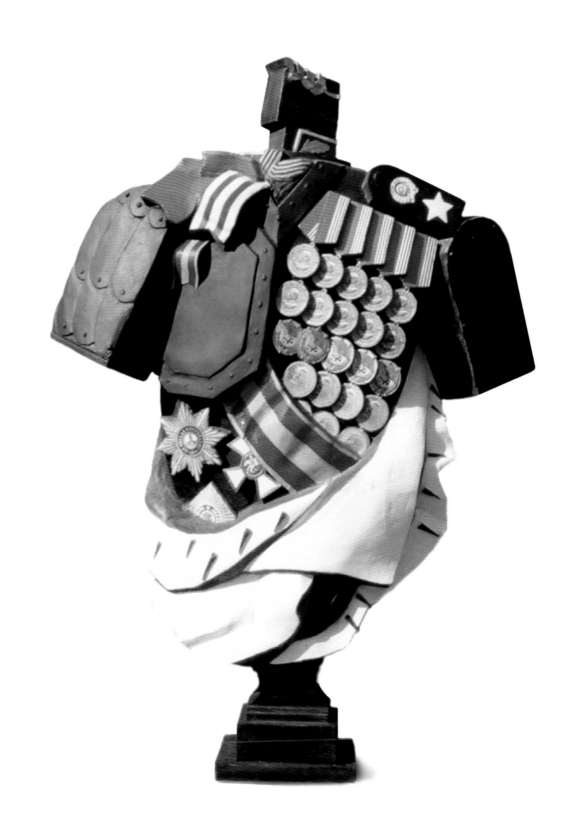

Vladimir OVCHINNIKOV

1941 –

Plate 66

**Banishment of the
Money Changers from
the Temple**

1982
Oil on linen
46⅜ x 31¼ inches
06261/1995.0697

Ovchinnikov was born in the Ural Mountain region and now works in St. Petersburg.

Although Ovchinnikov followed classical, academic traditions in his painting, he was *persona non grata* in Soviet Russia on a par with abstractionist and conceptualist artists. In his paintings, Ovchinnikov combines personages from ancient mythology, the Old and New Testaments, and figures from contemporary Soviet society to emphasize the ridiculous rules and the emptiness and difficulty of daily life in Soviet Russia.

In *Banishment of the Money Changers from the Temple*, Ovchinnikov refers to Jesus Christ's violent behavior in the Temple, where he castigated those engaged in unholy buying, selling and money-changing. However, instead of figures in traditional biblical garb, Ovchinnikov depicts ordinary Soviet people.

—m—

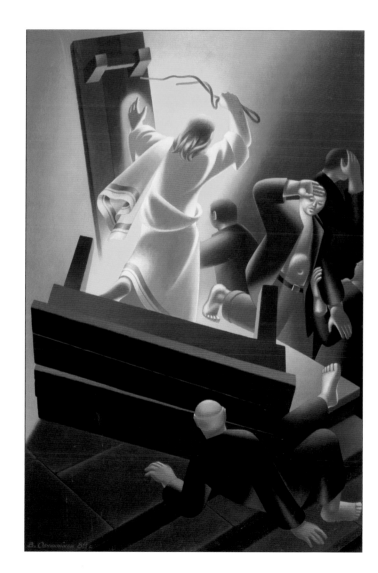

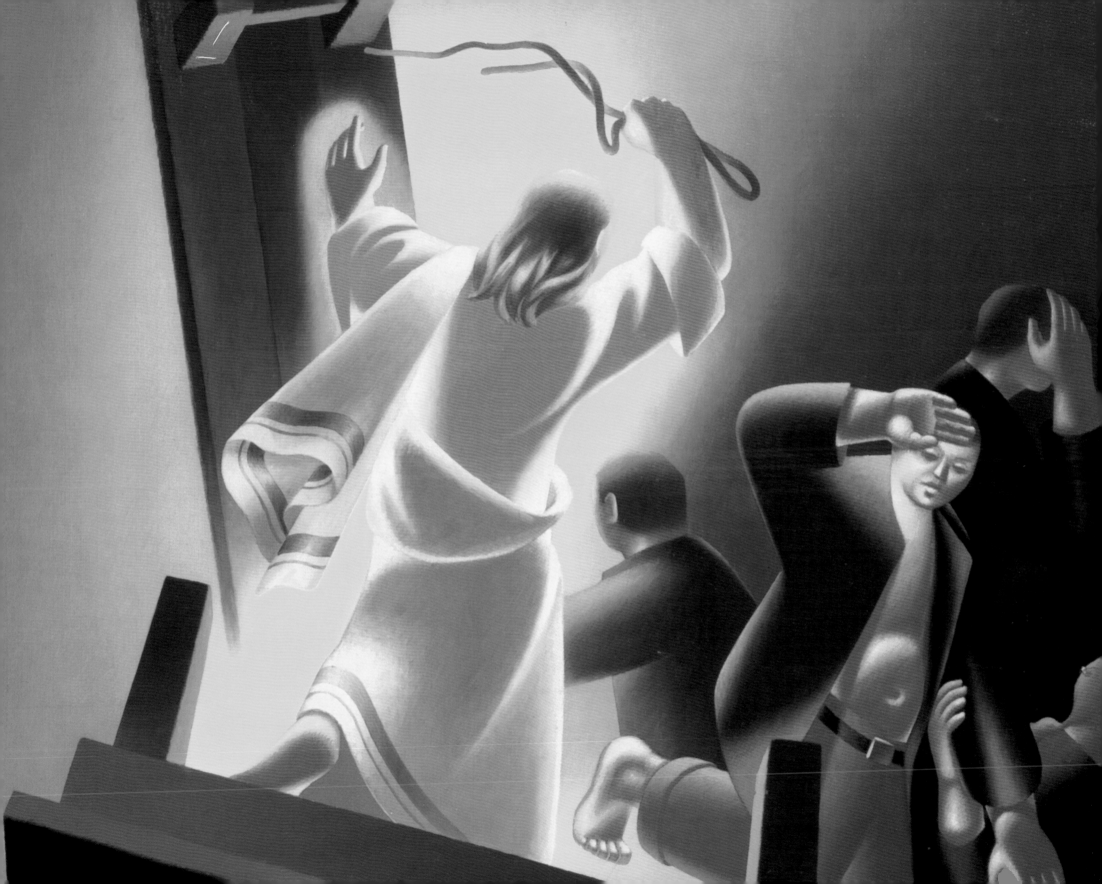

Oleg PROKOFIEV

1928 – 1998

Plate 67

The Window

1970

Oil on canvas

21⅞ x 25¼ inches

05215

Born in Paris, Prokofiev moved to Moscow at the age of eight. He attended Moscow Art School from 1944 to 1947, and in 1949 started an apprenticeship at the studio of Robert Falk. Prokofiev turned to abstract art as early as 1960. He was greatly influenced by the ancient art of India and Southeast Asia and wrote several books on the topic. In 1971, Prokofiev immigrated to Great Britain and settled in London. From 1972 to 1974, he studied art at Leeds University.

—⁓—

Oscar RABIN

1928 –

Plate 68

***Still Life with Fish
and Pravda***

1968
Acrylic and oil
on canvas
35⅛ x 43⅛ inches
16192/1998.1302

A Moscow native, Oscar Rabin played a central role as an initiator and driving force behind Moscow's unofficial art movement. In 1974, at great personal risk, Rabin organized an open-air exhibition that would come to be known as the Bulldozer Exhibition, so called due to the method of its destruction by the Soviet authorities. Always unpopular with the government, Rabin was arrested several times, and in 1978 he was stripped of his citizenship and exiled. Rabin now lives in Paris.

With his teacher, Evgenii Kropivnitsky, and Kropivnitsky's daughter, Valentina, whom he later married, Rabin established the Lianozovo Group, a community of artists living and working in Lianozovo, a suburb of Moscow. Members of this group differed in their styles, artistic philosophies and perceptions of the world; however, they were united by their uncompromising drive to fight for creative freedom.

In his paintings, Rabin depicted still lifes and imaginatively altered cityscapes. He often emphasized details such as religious symbols, street signs and newspapers that had personal and narrative significance. Rabin's unflattering presentation of his surroundings angered the authorities, who disapproved of his juxtaposition of fantasy with the harshness of Soviet reality—a violation of the prescribed style of Socialist Realism and an ironic commentary on its falsity. While somber tones prevailed in his palette, Rabin also produced unusual surface textures by mixing sand and wax with oil paint and adding gold leaf.

As in the present work, Rabin's still lifes treat subjects like smoked herring and a tumbler of vodka placed atop a torn copy of the Soviet official newspaper *Pravda*. The scholar Michael Scammell has observed that such imagery represented Rabin's commentary not only on the daily meal of the average Soviet working-class man, but also on the use the artist had for the Party newspaper.

—⁓—

Evgenii RUKHIN

1943 – 1976

Untitled

1971
Oil, acrylic, and
woven fiber on canvas
38¼ x 39 inches
18935

The artist was born in Saratov and worked in Leningrad.

Rukhin was one of the original forces behind the Leningrad unofficial art movement of the 1960s and 1970s. Although he died at the age of thirty-two in a mysterious fire in his Leningrad studio that was thought to have been started by the KGB, Rukhin was an extremely prolific artist, producing roughly 1,000 works during his brief career. A self-taught artist who had studied geology, Rukhin experimented with various surfaces and textures as he searched for new techniques. In 1968, he shifted from working in a purely abstract style to embracing a method that incorporated objects from everyday life that, in Rukhin's words, "civilization discarded as useless:" doors with rusty hinges, nails, locks and broken pieces of furniture.

Fearless in his activities as a nonconformist artist, Rukhin openly met with foreigners to learn about art outside the Soviet Union and to transmit abroad information concerning nonconformist art. Influenced by the works of Robert Rauschenberg and Jasper Johns, Rukhin juxtaposed monochromatic fields, richly textured assemblages and stenciled phrases. He participated in many underground apartment exhibitions, and was arrested as one of the organizers of the notorious 1974 Bulldozer Exhibition in Moscow.

—⁓—

Vasilii SITNIKOV

1915 – 1987

Plate 72

Portrait of a Mental Patient in Kazan

1942

Graphite on paper

10½ x 6⅝ inches

05918

The artist was born in Rakhitino, Russia, and worked in Moscow. He immigrated to New York where he died in 1987.

One of the members of the first generation of Moscow nonconformists, Sitnikov was exiled in the early 1940s to the small provincial town of Kazan, where he was diagnosed as schizophrenic and sent to a prison psychiatric hospital. Although he never received formal artistic training, Sitnikov was asked to create murals for the hospital. Without access to conventional artistic supplies, he was forced to produce his own pigments from mortar, chalk and other available materials. In 1944, Sitnikov was released from the hospital and moved to Moscow. He later became a mentor and teacher to a number of Moscow artists of the younger generation. In 1973, he was repeatedly interrogated and harassed by the Soviet government, and in 1975 he was forced to emigrate. Sitnikov went first to Austria and later settled in New York, where he died of heart failure.

Created during his stay in the psychiatric hospital, *Portrait of a Mental Patient in Kazan* is a drawing of a fellow patient confined in a straight jacket. The inmate's psychic pain is poignantly conveyed through his staring eyes, emaciated body and the absence of a mouth.

—⁓—

Leonid SOKOV

1941 –

Plate 73

Lenin and Giacometti

1990
Metal and bronze
18½ x 16⅛ inches
17466/2001.0511

Sokov was born in the village of Mikhalevo, Kalinin (now Tver) region. He worked in Moscow and now lives in New York.

Sokov graduated from the Stroganov Institute of Art and Design in 1969. As a student, he was inspired by the works of Aristide Maillol and Auguste Rodin. In his official capacity as a member of the Artists' Union, Sokov produced park statuary, especially of animals, and perfected his technique of welding and forging at the foundry he headed. By 1970, he had already begun his activity as an unofficial artist.

Lenin and Giacometti is one of Sokov's most famous works. In this piece, the artist placed on the same base two iconic figures from twentieth-century art history: Vladimir Lenin and Alberto Giacometti's *Walking Man* (1948). The pairing of the two figures represents the face-to-face confrontation not only of two sculptures, but also of two styles: Socialist Realism and modernism. The juxtaposition invokes the dialectical pair of avant-garde and kitsch as articulated by the noted American critic Clement Greenberg in his 1939 article on the subject. Sokov's use of bronze, however, suggests that both traditions belong to the realm of high art.

—⚶—

Alexei SUNDUKOV

1952 –

Plate 74

Line

1986
Oil on canvas
69¾ x 89¼ inches
14558

The artist was born in Maiskii, Russia, worked in Moscow, and now lives in New York.

Sundukov's work appropriates pictorial devices first explored by the group of nineteenth-century Russian realist painters known as the Wanderers or Itinerants. Sundukov, however, goes beyond the work of the Itinerants by not merely commenting on the conditions of Russian life, but also analyzing them. Unlike the Itinerants' realistic individualized images, Sundukov's figures are faceless masses of bodies responding mindlessly to the conditions surrounding them.

In the present work, anonymous men and women stolidly wait with eternal patience in a line that leads nowhere. Though Sundukov has created a dynamic diagonal, slicing the composition, the mood is still one of infinite drudgery and stymied anticipation. As an evocation of the misery associated with Soviet life, Sundukov's *Line* not only describes a frequent occurrence in Soviet daily life, it also captures a national feeling of interminable inertia. The life-size scale of the painting places the viewer at the end of the line, waiting as well for an unknowable, unattainable something.

—∿—

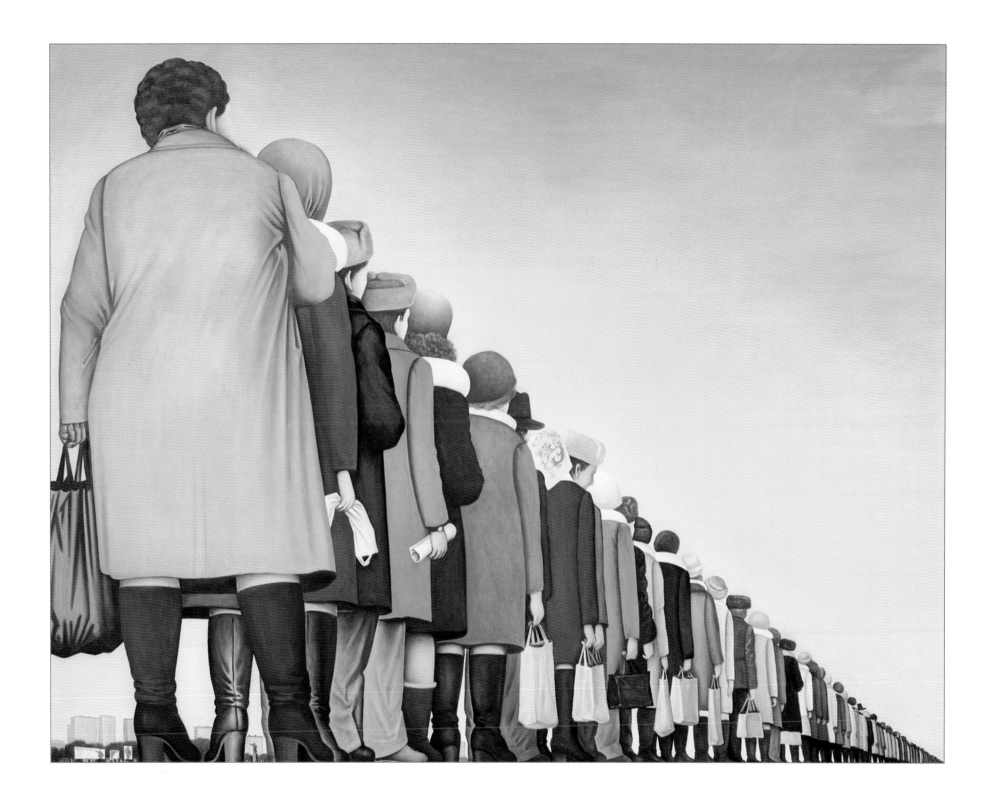

Boris TURETSKY

1928 – 1997

Plate 75

Untitled

1958
Ink on paper
32½ x 23¼ inches
20156

Born in Voronezh, Russia, the artist worked in Moscow, where he died in 1997.

Turetsky started drawing very early on. Already at the age of six, he was awarded a prize at the All-Union children's drawing competition. In 1947, Turetsky moved to Moscow and undertook the study of stage design at the Moscow Art School. There he first encountered Impressionism, Post-Impressionism and the Russian avant-garde. In the early 1950s, Turetsky became acquainted with the work of Piet Mondrian and Jackson Pollock and turned to abstraction. His earliest ink-on-paper abstractions, often untitled, have a limited palette of black and white. In 1959, Turetsky's abstract works were exhibited for the first time in the apartment of the musician Andrei Volkonsky.

The 1960s marked a turning point in Turetsky's creative career. He met Mikhail Roginsky and under his influence turned to figurative art. Turetsky's representational works of the time consisted of multi-figure groups set in public places such as subway cars. He did, nevertheless, continue to produce abstract works, including assemblages, paper construction and reliefs throughout the 1960s and 1970s.

—⁓—

Romanas VILKAUSKAS

1949 –

Interior X

1981
Oil on canvas
35⅛ x 43 inches
08739/1992.1048

After his graduation from the Vilnius Art Institute (now Lithuanian Academy of Fine Arts) in 1976, Vilkauskas moved with his family to the town of Siauliai, where he taught at the Art Department of the Pedagogical Institute. The career of this Lithuanian artist is permeated with a sense of history, of the intricate relationship that exists between the past and the present and that relates the life of the individual to that of the nation. Vilkauskas was deeply influenced by his mother's stories about his father's experience in the labor camps and by the stories about his deported relatives who fought for an independent Lithuania.

Vilkauskas opposed both the decorative, expressionist painting that dominated the local Lithuanian art scene of the 1970s as well as the grotesque and surrealist manner employed by some of his fellow artists. He started by creating works that, at first sight, are stripped of any ideological significance and treat such commonplace subjects as garage doors, yards, crumbling walls of pre-war factories, water pipes and smoke-blackened chimneys. He later, however, depicted quotidian subject matter precisely as a means of expressing his political views. His works are in striking contrast to the many official Soviet paintings that focused on dramatic events from Soviet history and centered on heroic and patriotic figures. Often rendered in subdued colors and gloomy tones, Vilkauskas' works lack the optimism and heroic posture characteristic of Socialist Realism.

—m—

Bibliographical Information

The main sources for artists' biographies include: *A-YA Journal: Unofficial Russian Art Revue*. Paris, New York, Moscow, 1979. ▪ Bar-Gera, Kenda, and Jacob Bar-Gera. *Wladimir Nemuchin*. Köln, Germany: Galerie Bargera. ▪ Bowlt, John, and Garrett White, eds. *Forbidden Art: The Postwar Russian Avant-garde*. New York: Distributed Art Publishers, 1998. ▪ Bown, Matthew Cullerne. *Contemporary Russian Art*. Oxford: Phaidon Press Limited, 1989. ▪ Goodman, Susan Tumarkin, ed. *Russian Jewish Artists in a Century of Change 1890-1990*. Munich: Prestel, and New York: The Jewish Museum, 1995. ▪ Hillings, Valerie. *Russia!*, biographical entries for the catalogue. New York: The Solomon R. Guggenheim Museum, 2005. ▪ Khidekel, Regina. *Soviet & Post-Soviet Sots Art and American Pop Art*. Minneapolis: University of Minnesota Press and the Frederick R. Weisman Art Museum, 1998. ▪ Kashouk, Larisa, ed. *Boris Turetsky (1928-1997)*. Moscow: State Tretyakov Gallery, 2003. ▪ Levkova-Lamm, Innesa. *Rostislav Lebedev: Paintings Objects Installations*. New York: Eduard Nakhamkin Fine Arts, 1990. ▪ Liutkus, Viktoras. *Contemporary Lithuanian Artists: Romanas Vilkauskas*. Lithuania: artseria, 2003. ▪ Obukhova, Aleksandra, et al. ed. *Mikhail Roginsky: Pedestrian Zone Painting 1962-1967, 1995-2002*. Moscow: State Tretyakov Gallery and the National Centre for Contemporary Art, 2003. ▪ Roberts, Norma, ed. *The Quest for Self Expression: Painting in Moscow and Leningrad 1965-1990*. Ohio: Columbus Museum of Art, 1990. ▪ Rosenfeld, Alla, and Norton T. Dodge, eds. *From Gulag to Glastnost: Nonconformist Art from the Soviet Union*. New York: Thames and Hudson, in association with the Jane Voorhees Zimmerli Art Musuem, 1995. ▪ Sharp, Jane. *Realities and Utopias: Abstract Painting in The Norton and Nancy Dodge Collection of Nonconformist Art from the Soviet Union*. Jane Voorhees Zimmerli Art Museum, 2000. ▪ Tupitsyn, Margarita. *Leonid Lamm: Recollections from the Twilight Zone 1973-1985*. Mechanicsville, MD: Cremona Foundation, Inc., 1985.

Acknowledgments

■ The conceptualization and development of *Soviet Dis-Union: Socialist Realist and Nonconformist Art* required the contributions of numerous individuals and organizations that share a commitment to expanding the American public's appreciation for the creative accomplishments of the artists of the former Soviet Union.

■ The Museum of Russian Art recognizes the contributions of Reed Fellner, Curator and Exhibition Designer, and Joan Lee, Director of Communications, for their tireless efforts to bring this exhibition to fruition. Gini Tyson, Jane Frees-Kluth, Janelle Allen, Greg Dickerson and Sarah Brunsvold participated in the installation of the exhibition. Peter Schmidt, Scott Nagel, Douglas Johnson and Melanie Brooks assisted in coordinating the myriad details to ensure the timely opening of this joint exhibition. Maria Bulanova, art historian from Moscow, has written extensively on the subject of Socialist Realist art. Lynda Holker and Carol Veldman-Rudie have directed docent training and tour scheduling.

■ The staff of the Jane Voorhees Zimmerli Museum of Fine Art at Rutgers, The State University of New Jersey, has continually provided professional expertise to this venture. Greg Perry, Director, provided administrative support, while Dr. Alla Rosenfeld, Director: Department of Russian Art and Senior Curator of Russian and Soviet Nonconformist Art has written extensively on Nonconformist art and provided invaluable technical assistance. Cathleen Anderson, Registrar, Leslie Kriff, Associate Registrar and Dasha Shkurpela, Registrarial Assistant, coordinated complex photographic requirements and the shipment of artwork. Kim Sel, Graduate Research Assistant for the Dodge Collection, assisted Dr. Rosenfeld in compiling narrative texts.

■ Jane Friedman, Chicago, Illinois, provided important editorial services. The Bill Moeger Design Studio designed the exhibition brochure, event catalog and promotional materials.

■ This exhibition would not have been possible without the continuing commitment of the principal lenders: Raymond and Susan Johnson, and Norton and Nancy Dodge.

On behalf of the trustees of The Museum of Russian Art, I want to express my appreciation to all those whose contributions of time and creative energy have made this exhibition possible.

Bradford Shinkle, IV

President
The Museum of Russian Art

Index of Socialist Realist Artists and Works

Index of Nonconformist Artists and Works